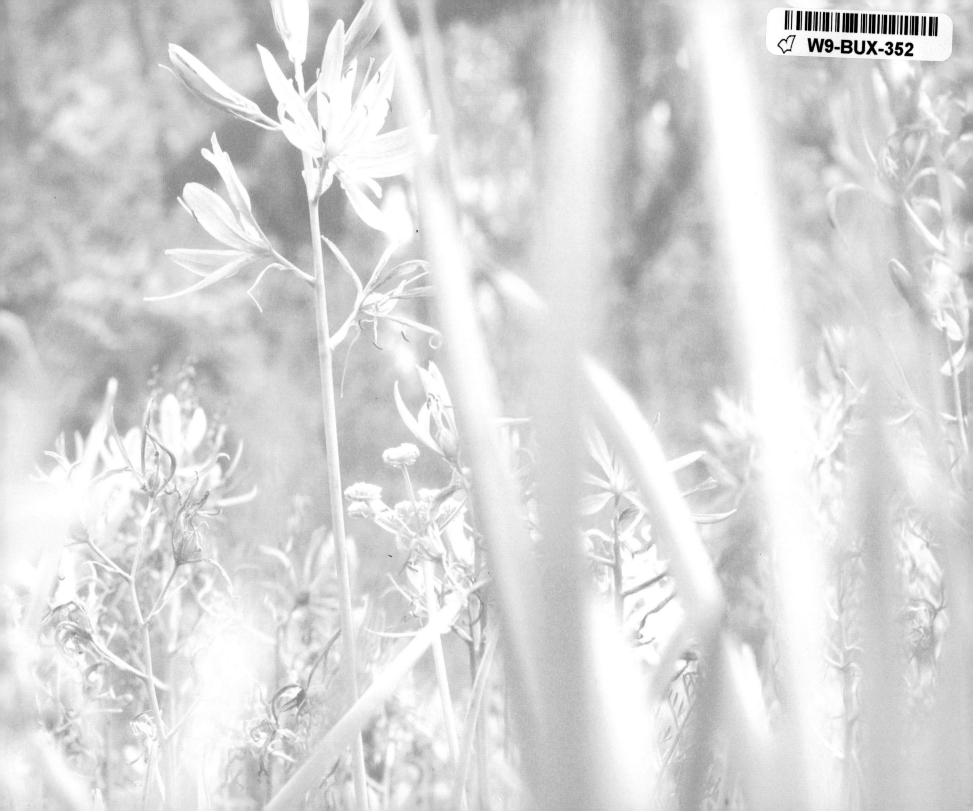

WOLF HAVEN

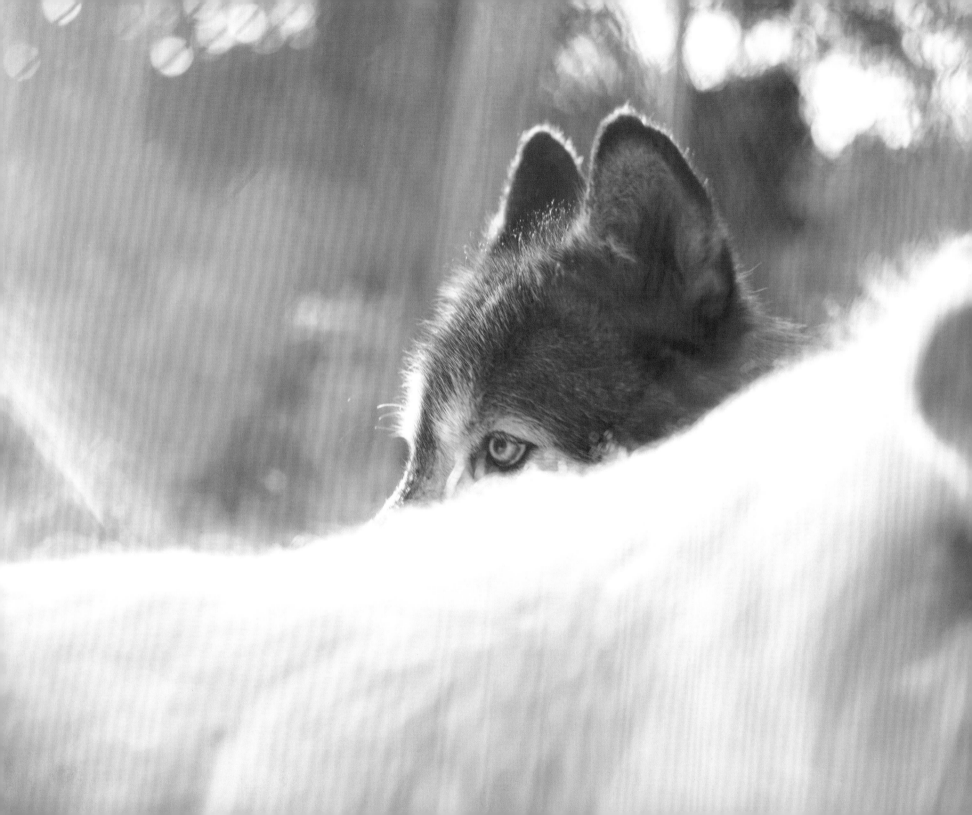

WOLF HAVEN

*Sanctuary and the Future of Wolves
in North America*

Photography by ANNIE MARIE MUSSELMAN
Essay by BRENDA PETERSON

SASQUATCH BOOKS
SEATTLE

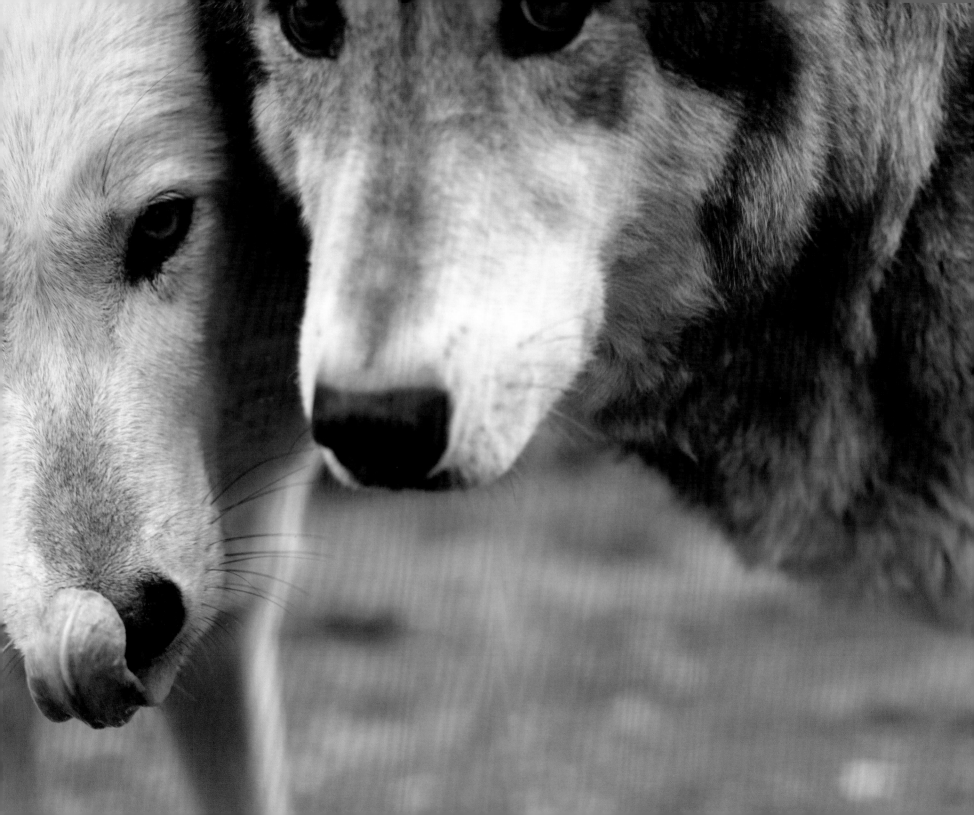

CONTENTS

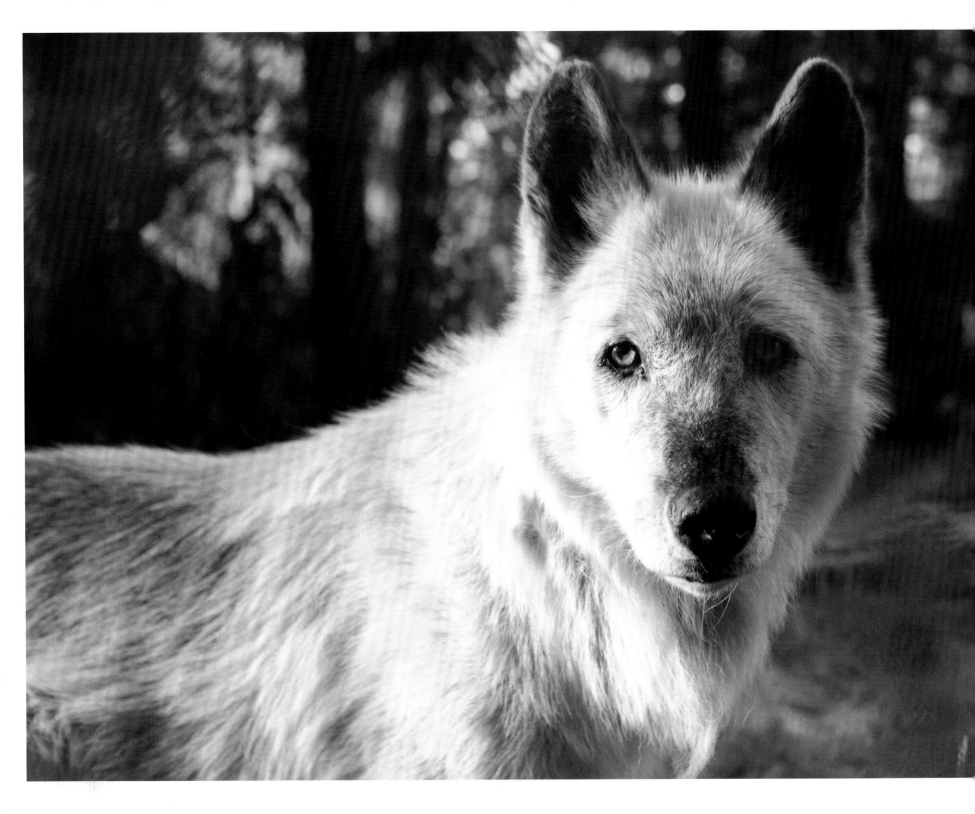

WOLF EYES

Their eyes find you first, often golden or dark green and amber-flecked with a fierce and surprising intimacy. Direct, intelligent, eerily familiar. Though these wolves in their refuge are no longer wild, there is nothing tame in their gaze. Instead, there is a rich and vivid emotional life that we can somehow read, not just because humans have lived closely with *Canis lupus* since prehistory, but also because the wolves mirror us. And even behind fences, they connect. *First contact.*

One white wolf's stare is stunning—Bart commands our complete attention, even as he rests, with his lean legs almost casually crossed. Lonnie's eyes are shy but steady as he peeks out from behind branches. His expression reminds us that in the wild wolves are extremely wary of humans and spend most of their lives hiding from us. Delicate Lexi with her flattened agouti-colored ears looks back cautiously at us as she retreats. Tala, the slender red wolf, steps so lightly and silently out of his hiding place that he startles us. Lowering his sleek mahogany head, he gives us a quick searching glance—and then disappears.

Even the abandoned wolf dogs—those who, as Wolf Haven's director of animal care, Wendy Spencer, says, are "caught between two worlds"—

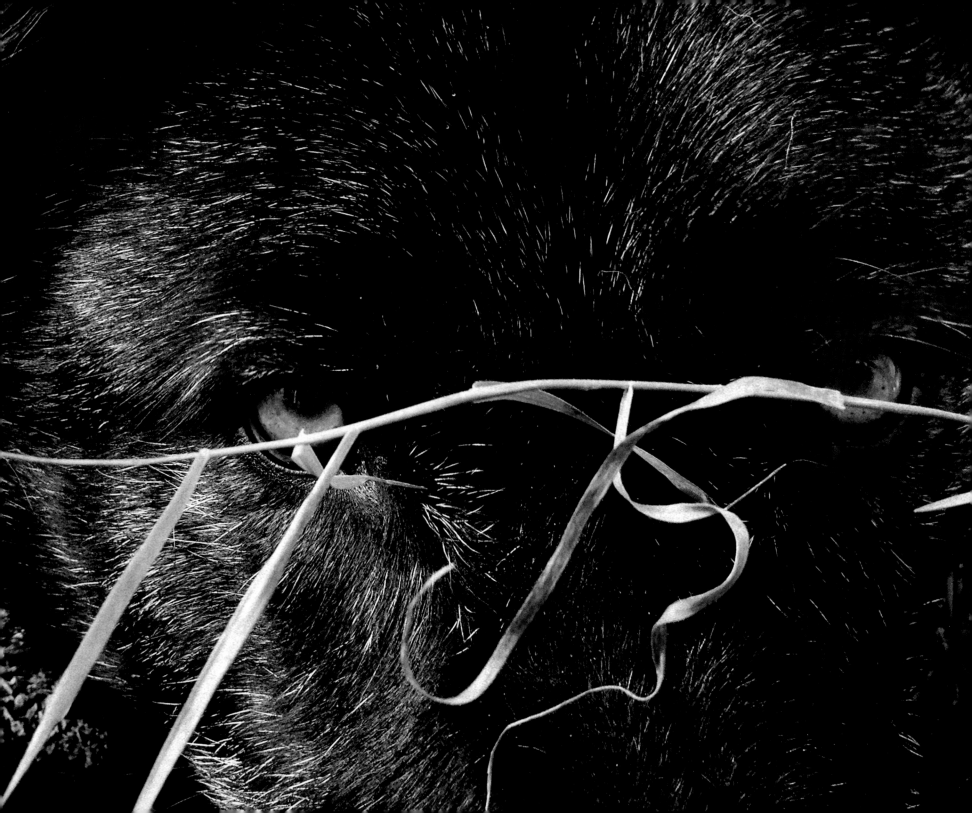

haven't lost the wildness or expressive depth in their eyes. Caedus, the lustrous black male wolf dog who shares his life with the delicate and somehow sad-eyed Ladyhawk, stands sentry; his buttery eyes both bold and curious. He might as well be perched protectively atop a remote mountaintop, scanning for his pups and family.

How many of us have actually ever had the privilege of looking into the eyes of a wolf? How many of us would ever know if a wolf was secretly watching us in the wild? We couldn't smell them the way wolves can scent humans from half a mile away. We couldn't hear them, unless they howled. Sight is the only way we sense a wolf, so they are at the advantage when it comes to sensory gifts. And even then, the wolf's unblinking and powerful gaze is unusual in our species. Perhaps that's why we stand riveted at the fence or in the forest when we catch a glimpse of this fellow creature.

"Wolves look right through you, don't they?" a Yellowstone biologist once asked me in 1995 as we watched the first reintroduced wolves, the Soda Butte family, scamper with their pups and stride across a high meadow. Even from half a mile away, the wolves were keenly aware of our presence.

"Yes, they do," I breathed, barely able to hold the telescope, my hands were trembling so.

Yes, I still feel that intense energy running between wolves and humans every time I visit Wolf Haven and encounter these animals who have found a retreat here since it opened in 1982—giving sanctuary to over two hundred gray and red wolves, plus wolf dogs and even coyotes. We recognize ourselves in wolves—our own hungers, passions, violence, and tenderness. Anyone who spends time with wolves understands that their social dramas—who's in, who's out, who's on top, who's struggling to survive, who's ailing or lost, who is thriving—are as fascinating as our own. In the wild, wolves live in close-knit and complicated families. They are affectionate and loyal to their young, and the whole group cooperates to

PREVIOUS PAGE: *Mehina, a female gray wolf, is a fifteen-year resident of Wolf Haven.*

LEFT: *Caedus, a male wolf dog, was born in 2007 and came to Wolf Haven in 2009.*

survive together. At Wolf Haven these often abandoned, abused, mistreated, and misunderstood wolves are given another chance, not only at living, but also at intimate relationship with one another.

A lone wolf is a rare wolf. All you have to do is hear a wolf howl to intuitively know that wolves always seek community. Just like their profound eye contact, the wolf's howl is a language of loss and longing—and sometimes even joy—that we also instinctively understand. As you enter this book of *Canis lupus* portraits and stories, remember that you are in the presence of an animal who has always belonged very near us. Another top predator who has inspired in us both passionate devotion and unjustified cruelty. Another animal who even in a shelter is very much our equal: a spirit that can still hold and forever meet our eyes.

RIGHT: *Jesse James, a female gray wolf.*

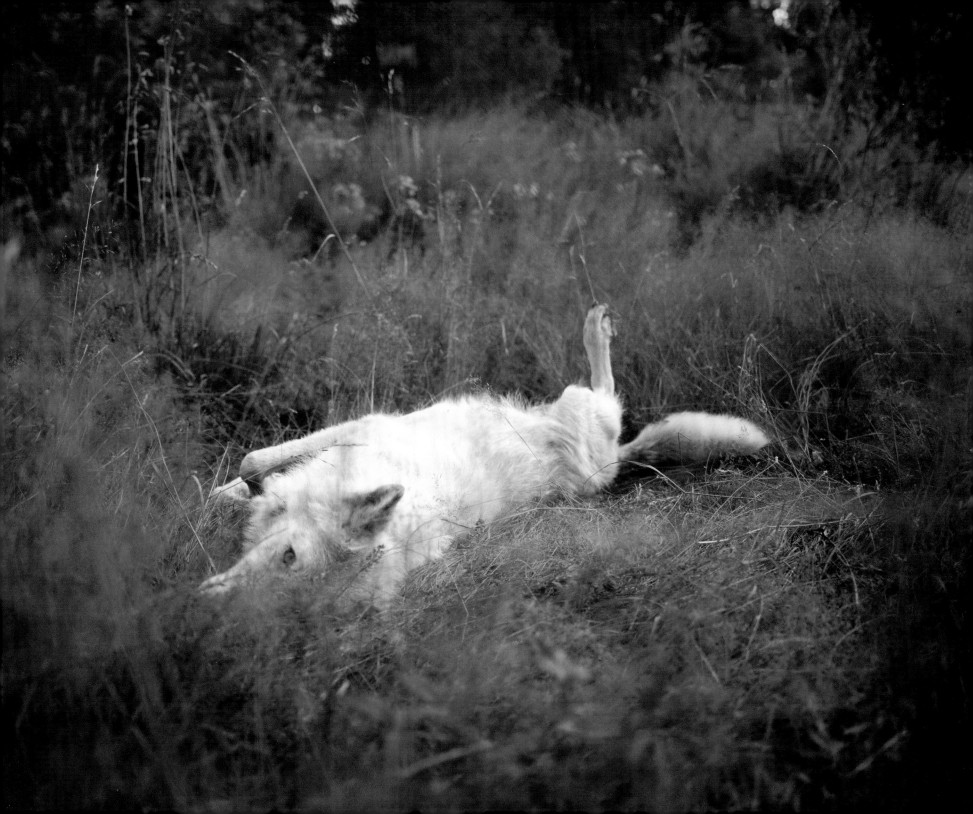

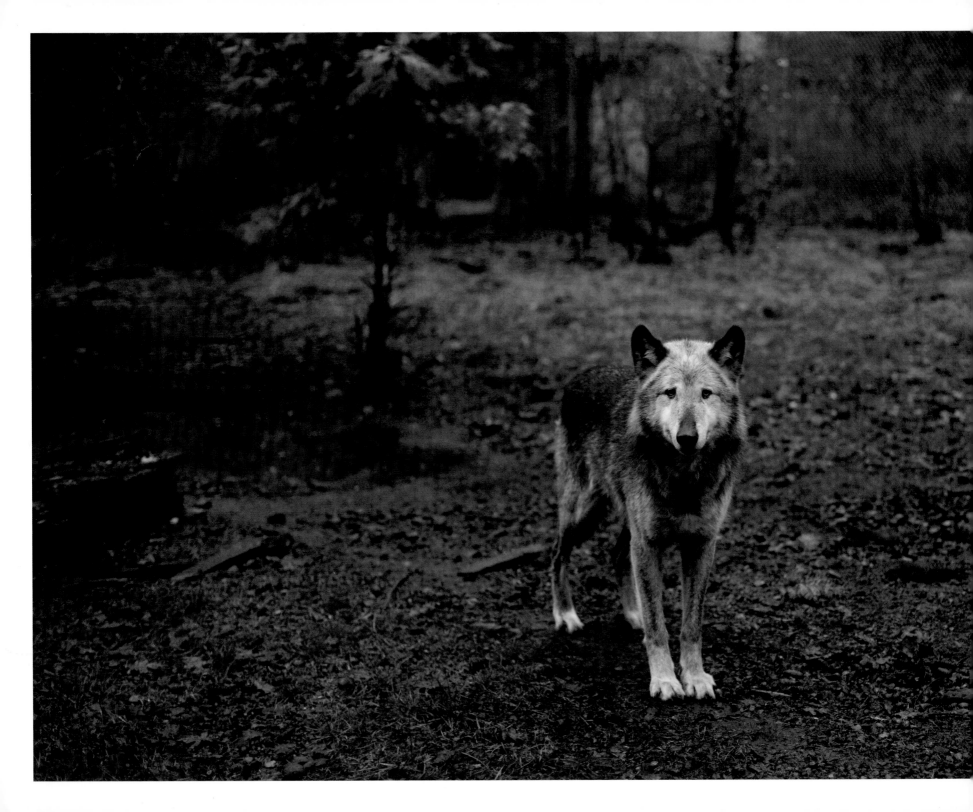

BLUE MOON HOWL

The summer heat of the day has slipped into fragrant, cool shade, and a full moon shines over head. The sanctuary is still and the wolves are resting but watching. Always watching. London and Lexi, Caedus and Ladyhawk, Juno and Shadow, Diablo and Gypsy. Carefully grouped together, two by two. Biologists define a wolf family as two animals living together. Here, in their forever homes, the wolves find their family and a haven. Here, they form complex, intense, and highly social bonds.

Shadow, a tall and stunningly handsome young male wolf, is never far from his companion, Juno; he shadows his female elder, which he has done ever since he arrived to find refuge here at Wolf Haven when he was only six months old. Shadow was already a survivor of five foster homes. Now he stands in long-legged profile, his black-tipped ears pricked to listen to our whispers. His shed-out summer fur is silver and streaked with charcoal shadows; his amber eyes hold ours with an expression of fierce intelligence. He is majestic and yet somehow vulnerable.

"These wolves are hypersensitive to everything—to each other and even to us," explains Wendy Spencer, director of animal care at Wolf Haven. "When Shadow first arrived at Wolf Haven, he really needed to connect with another wolf. Some high school boys had bought him from a Washington breeder for $2,500 and tried to raise him in an apartment."

Wendy pauses with just the shadow of an understated smile on her lips. "A wolf in an apartment . . . you can *imagine* how well that worked."

Trying to control a large, active wolf in a tiny place, the teenage boys abused and starved Shadow. His tail was dislocated, and the pup was passed along to people who didn't understand wolf biology. Shadow was bounced around through many owners until he finally found his lifelong sanctuary at Wolf Haven. He is now five years old.

"This is *it* for him," Wendy says with a protective nod, then adds proudly, "He's home."

Wolves will never be tamed; they will never be dogs. They must never be our pets. Many of the wolves and wolf dogs are here in this sanctuary because of our misguided greed to possess a wolf of one's own. This is a tragedy for both wolves and humans. A wolf dog is not at home in his own skin and is often torn between his wild nature and the human demand that he be domesticated, docile, *tamed*. Wolves belong in the wild, not our living rooms.

Yet wolf breeders get thousands of dollars per wolf and the market for them is international. After his wolf escaped and attacked a German shepherd, one Washington State wolf breeder told a local TV station, "I want to breed *down* the wolf . . . so they look like wolves but are *not* wolves."

This local breeder used to discipline his wolf, Lakota, by punching him in the head. When the wolf finally attacked the breeder and escaped to run through the town, the man decided just to euthanize him. The vet called in for this sad job was also one who tended the animals at Wolf Haven. Happily, Lakota was saved and accepted into sanctuary here. At first Lakota was frantic and needy, especially for female attention. But the idea was to wean him off of humans because it's much better for animals if they are self-reliant and animal bonded. Lakota is a gorgeous gray wolf with a dark stripe down his nose and the archetypal ashen buff cape. He is now

PREVIOUS PAGE: *Ladyhawk, a female gray wolf, is a partner with Caedus.*

RIGHT: *Sweet-tempered Jesse in the summer grass.*

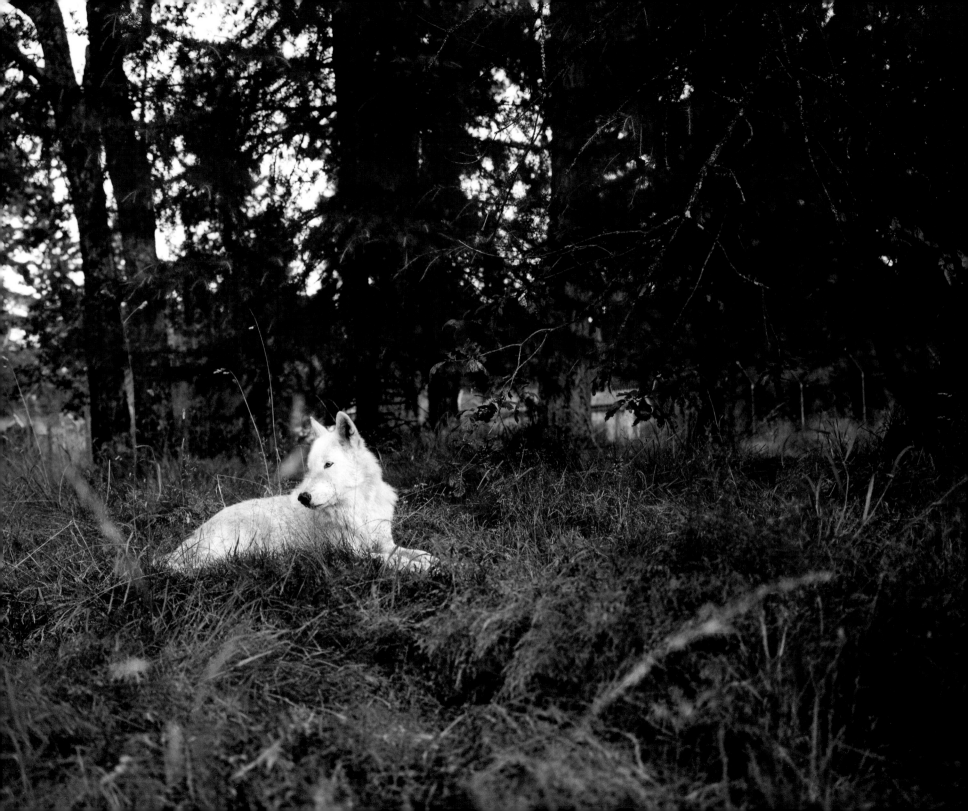

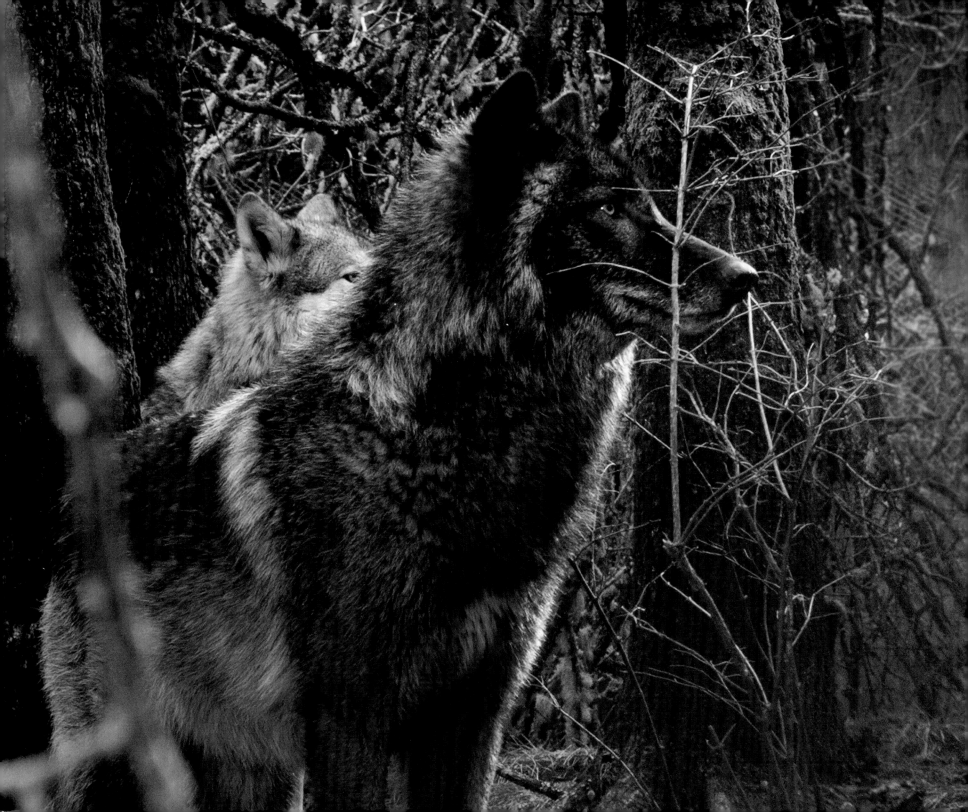

companioned with Sequra, a fourteen-year-old wolf dog, who looks like a feminine mirror of Lakota. She is this once-troubled wolf's matriarch and elder sister. Extremely patient and tolerant of Lakota, Sequra has taught him how to be a poised and self-contained wolf and to enjoy the respectful relationship with his own kind.

Wendy and I talk about this human need to tame what is wild as we watch. We wonder, *Why insist on owning and domesticating everything?*

"These wolves always come first," Wendy says firmly. "Here, it's what the wolves need, not our human need for connection."

We watch Shadow venture nearer us but with one ear turned back to track Juno, almost hidden behind him in the trees. "At first Juno wanted nothing to do with Shadow," Wendy continues. Shadow was desperate for Juno's attention and her care, for the companionship of his own kind. Kinship. Now Wendy does smile. "After a few weeks of the pup anxiously following Juno around . . . well, she finally surrendered to Shadow. And now, they are inseparable."

For just a moment, cream-colored Juno emerges from the trees, as if to check on Shadow and the few human visitors. The sanctuary is empty except for the four of us—Annie Marie, several cameras slung around her neck; Wendy Spencer; a friend, Tracey; and me.

"He's perfect," several of us say at once as Shadow lopes even nearer us, his eyes never leaving ours. Shadow engages more readily with people than most wolves, who are wary by nature.

"He *is* perfect," Wendy echoes. "Perfect and lean by design."

In the wild wolves are equally lean and can run up to forty miles per hour as they pursue their prey. I imagine Shadow speeding and racing over a meadow after a deer, his whole family alongside him. Those long legs are a blur of black and silver, reminiscent of the old Russian proverb, "The wolf is kept fed by his feet." Shadows of the full moon shine silvery

gray through the trees. The *Farmers' Almanac* calls July the "Full Buck Moon," because this is when the bucks begin to grow their velvet antlers. This is also when wild wolves, lean and lovely like Shadow, are stalking and chasing down deer. This evening is an unusual "blue moon" because it's the second full moon of the month.

During the summer Wolf Haven hosts several overnight events on the campground, offering a more intimate experience with wolves. At this event, called A Midsummer's Night, the visitors learn much about the sanctuary wolves. They also hear Wolf Haven executive director, Diane Gallegos, explain their vital and nationally recognized conservation programs, including the captive-breeding program called Species Survival Plan (SSP). Through its captive-breeding program, Wolf Haven is helping to restore the highly endangered Mexican gray wolf. In this program Mexican gray wolf pups born here are candidates for reintroduction back into the Southwest to a wild population that is facing extinction.

"So . . . are *you* all ready to howl?" asks Wendy.

Eagerly we all nod, "Yes, ready!"

"Okay," Wendy says firmly. "Send out only good thoughts. Then, please stop howling and just listen when you hear the wolves. One, two, three!"

We cup our mouths and raise our heads to the sky. Above us, equipoised and opposite the moon, is the fading sun. Its last long light streams through the evergreens.

"Ahhhhhooooooooooh!" We howl in surprising harmony—my mezzo-soprano, Annie's rich alto, and Tracey's *yip-yip-yip-ooooooooh* practiced from years of living alongside Siberian huskies.

It's only two seconds before a single high-pitched howl answers us, followed by a full-bodied chorus of wolves: wild singers in plaintive,

PREVIOUS PAGE: *Shadow (left) lived in five different homes in the first few months of his life before coming to Wolf Haven. Juno, a wolf dog, is Shadow's partner.*

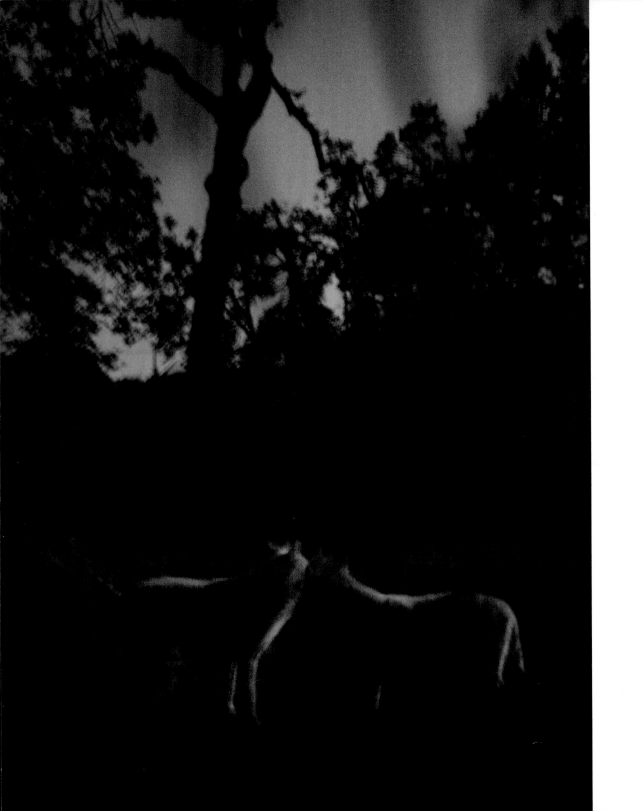

LEFT: *Spruce (left) and Jaque try moonlight.*

long phrases. It's a wolf opera with baritone barks, soaring soprano arias, and almost ultrasonic whines. Each wolf has a distinctive voice.

"Listen," Wendy says as she cocks her head. "That's London. His howl is the lowest."

We listen, transfixed, heads tilted way back to better hear. The multitudinous wolf howls rise higher, ecstatic and strong, a simple rejoicing in their vocal communion. It's as if they're singing out to each other: "Here we are! Found each other again. We are together."

"That's Shadow," Wendy whispers as the young wolf's throaty tenor syncopates with the wolf choir like a kind of canine percussion.

Juno bounds forward out of the trees to lift her tawny head, her howl mournful and hoarse; the elder holds down the rhythm for the rest of the wolves. The wolf dog, Caedus, and his wolf partner, Ladyhawk, raise their snouts skyward in an exhilarating duet. It seems to inspire all the other wolves to more jubilantly join the singing. Even the coyotes jump in now, their sharp yips a staccato counterpoint.

Now Shadow and Juno again take the lead—their songs in perfect sync, the younger Shadow's steady wail and Juno's tender moaning. At last the Mexican wolves, Gypsy and Diablo, blend their melodious voices—a tone at once exuberant and somehow full of longing. These Mexican wolves are the original *lobos*.

This woven wolf music is haunting and yet recognizable, as if we've always heard this in our ancestral cells—the hard-wired call-and-response between humans and wolves. Trees throb around us with the wild echoes. This is how our forests sounded for millennia, when millions of wolves roamed their native habitat. This is what our prehistoric ancestors heard around midnight fires in their caves—before they invited the wolves inside to live alongside them as companions and hunting allies. This howling is both of our species' birthrights.

Why do wolves howl? They are *not* howling at the moon, magnificent as it is rising over us. Science has proven that to be a myth. Researchers have discovered that wolves howl for many vital reasons: to communicate with their group, to signal their return from the hunt, to sympathize with other family members who are caught in a trap or hurt. In the wild it can be risky for a lone wolf to howl in seeking his family, since that can give away his exact location to a rival group. The late Alaskan wolf biologist, Gordon Haber, author of *Among Wolves*, says that sometimes wolves howl "to energize the group after a rest, as a form of socializing that helps

RIGHT: *Caedus and Ladyhawk posturing for attention.*

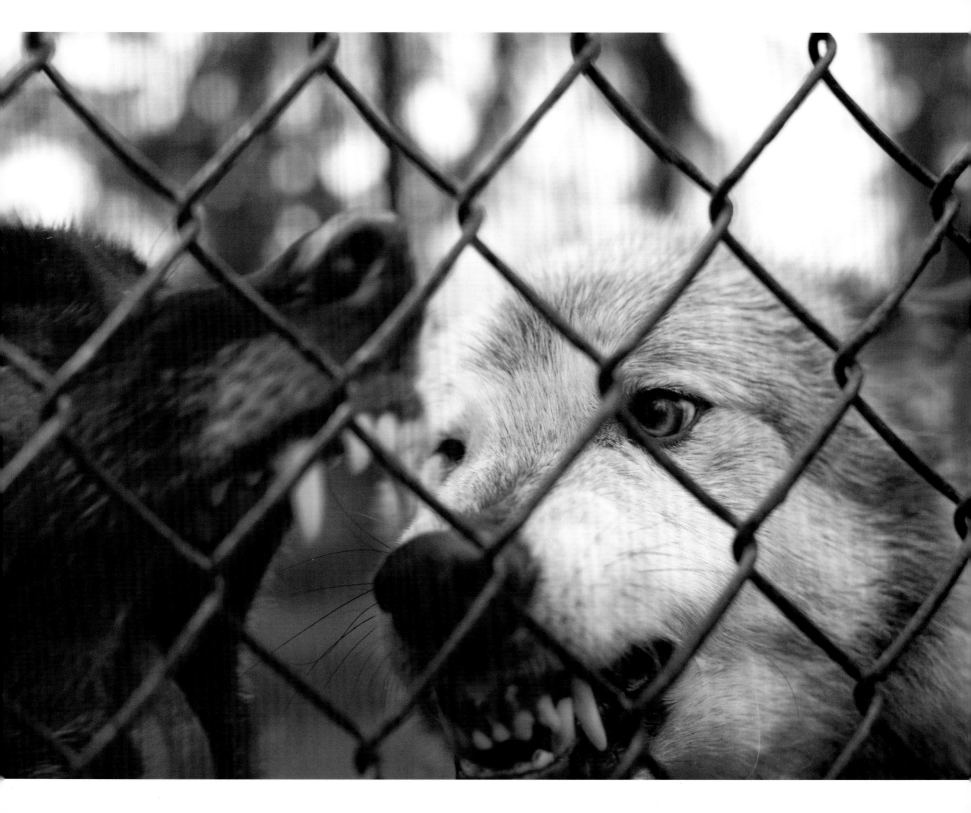

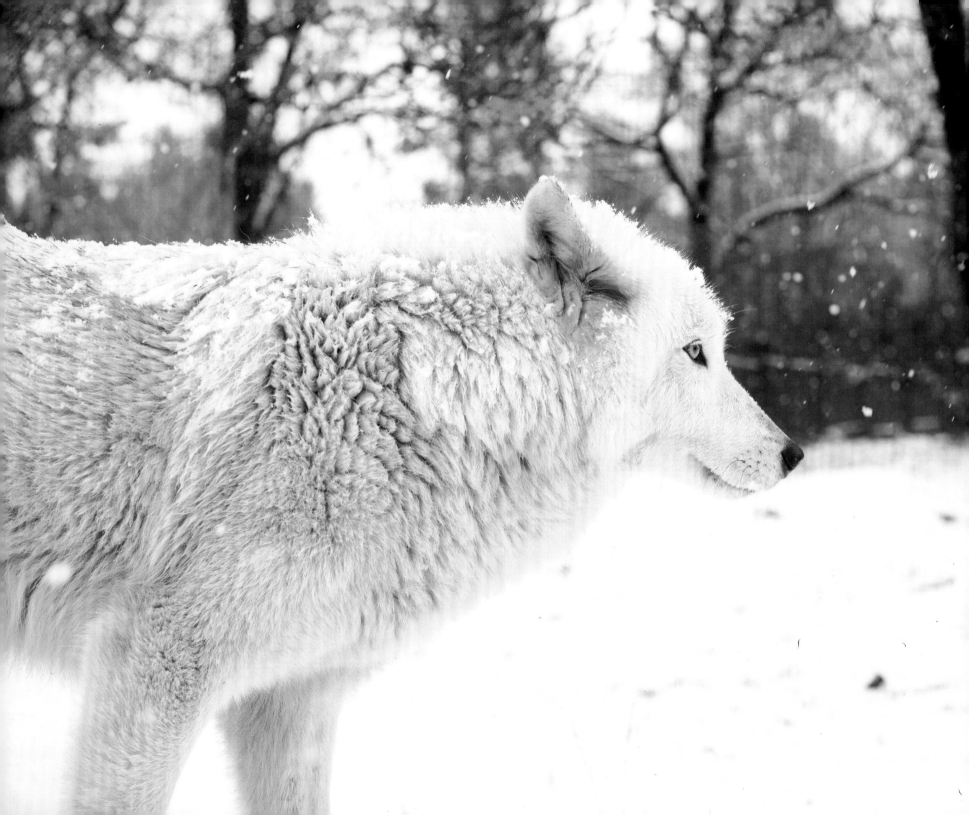

to maintain important bonds, to express a range of emotions, to advertise their territorial boundaries, and simply for the joy of howling."

We are certainly joyful as we raise our various devices to record the dynamic crescendos of wolf song. It's difficult for us not to instinctively join in again with the wolves. Why do humans howl? Babies do it before they can talk. Teenagers do it careening around the corner in their fast cars. Adult males often do it to show attraction to a woman. In some cultures mourners howl in elegy for their dead. It's so natural to lift one's voice in a long fulfilling howl. All ages howl along with their domesticated dogs. Why?

LEFT: *Jaque in the first snow.*

RIGHT: *Caedus at the fence.*

Companionable howling is in our shared social behavior and neurobiology. About thirty thousand years ago—when either wolves domesticated us or we domesticated wolves to live alongside us as dogs—our Paleolithic hominid ancestors were intensely aligned with other animals. On prehistoric cave walls, it is animal drawings of wolves, deer, bison, big cats, and mammoths that are most fully detailed. Cave paintings of animals are anatomically correct, and colors are bright with devotion and close observation. Early humans must have observed wolves using their cooperative hunting skills, and perhaps we even scavenged from their kills. Our modern dogs and gray wolves share a common ancestor from an extinct wolf living thousands of years ago.

Maybe when we howl, we are simply remembering that human-wolf bond in our brains and bodies. In her book, *Made for Each Other: The Biology of the Human-Animal Bond*, Meg Daley Olmert documents that living so closely with wolves "leaves a neurobiological mark on social mammals." The nourishing brain chemical oxytocin floods our brains with pleasure and connection when we align with other animals. Researchers have found that even just visual contact with animals produces in us this beneficial oxytocin. Even more than a good marriage, a close, daily bond with animals increases heart health and longevity. Olmert concludes, "We and our wolves emerged from the Ice Age more optimistic, gregarious, content, and cooperative. We emerged as friends."

This seems like the most basic reason both wolves and humans howl—we call out to each other in friendship. A recent ABC News article, "Why Do Wolves Howl? Love, Scientists Say," explains "wolves howled the most when they had a special relationship with the missing member of the [family]."

RIGHT: *Lonnie was found at a young age wandering in a cemetery in Los Angeles.*

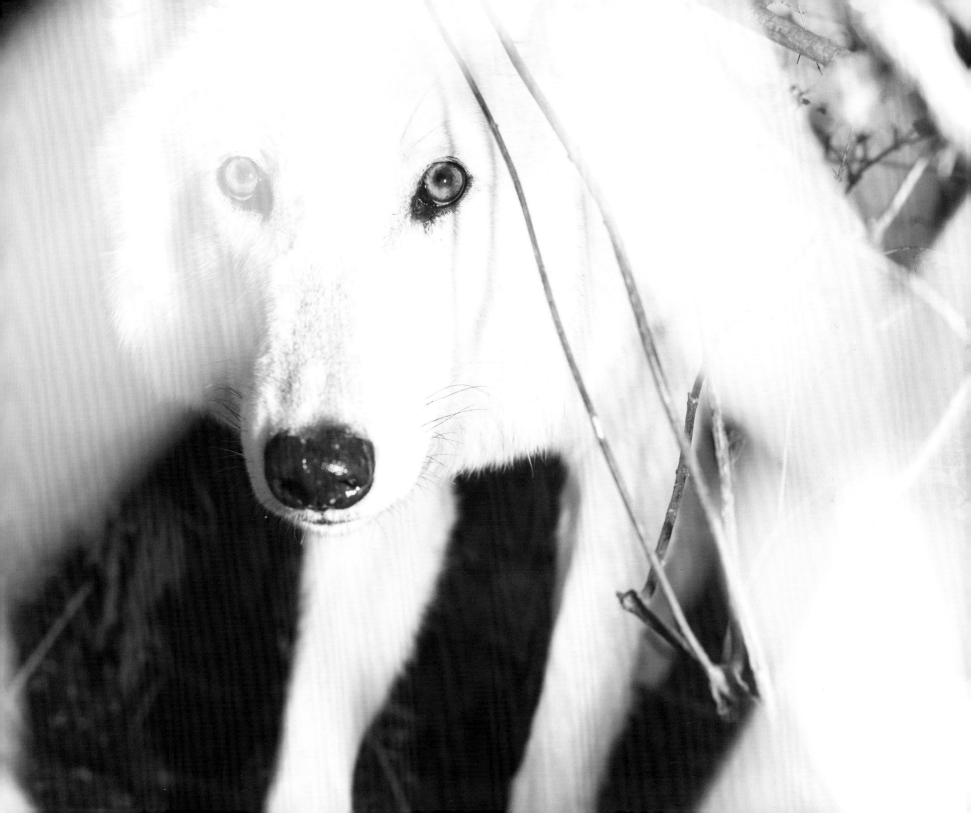

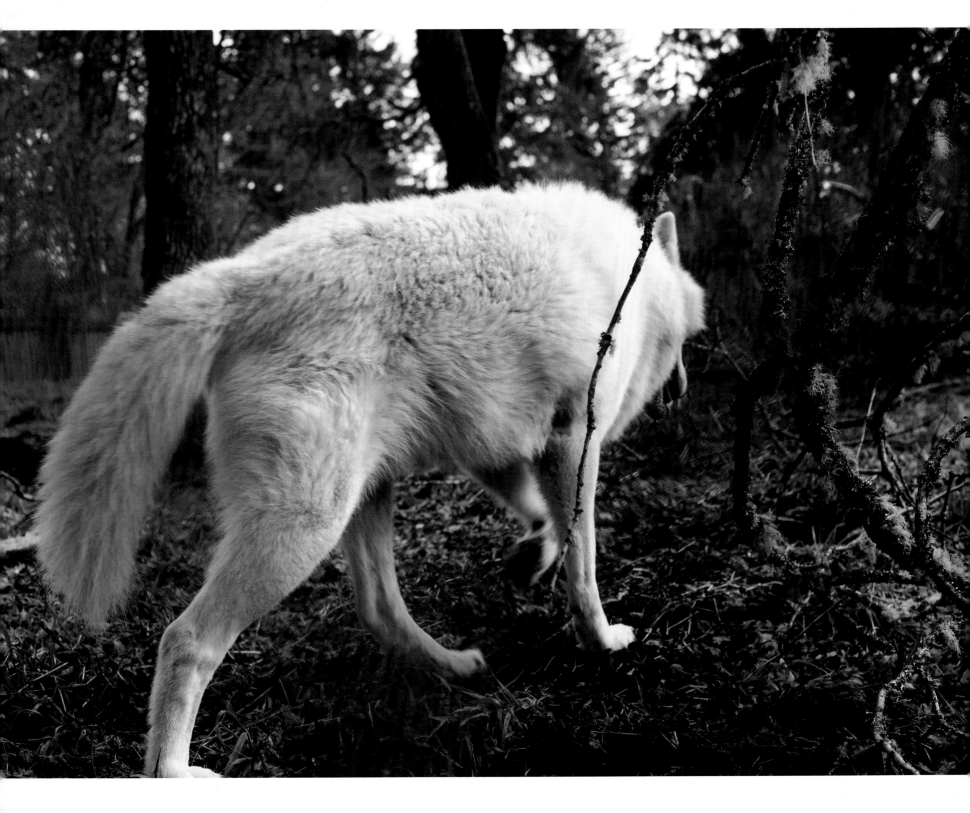

For too long, we've been missing as members of the wolf family. Missing links. There is such sadness in the modern loss of such a closely cooperative and ancient bond. Here at the wolf sanctuary, surrounded by the *Canis lupus* voices who have been disappeared and silenced from our forests for too long, I couldn't help but feel we were hearing both a requiem and the returning welcome of a family reunion.

The wolves' howling suddenly fell into a low wavering lament. I didn't ever want the howling to end. I want to always hear wild wolves in the forest singing together like this. Only a few stragglers in the sanctuary offer a soft coda: sharp yipping, rhythmic barks, and then one last treble howl. Finally, silence. Only the breeze is still whispering and warm through branches. Like a sentry Shadow stands near us, very close at the fence, his golden eyes wide open. What does he see? What does he understand?

RIGHT: *Jaque about to pounce.*

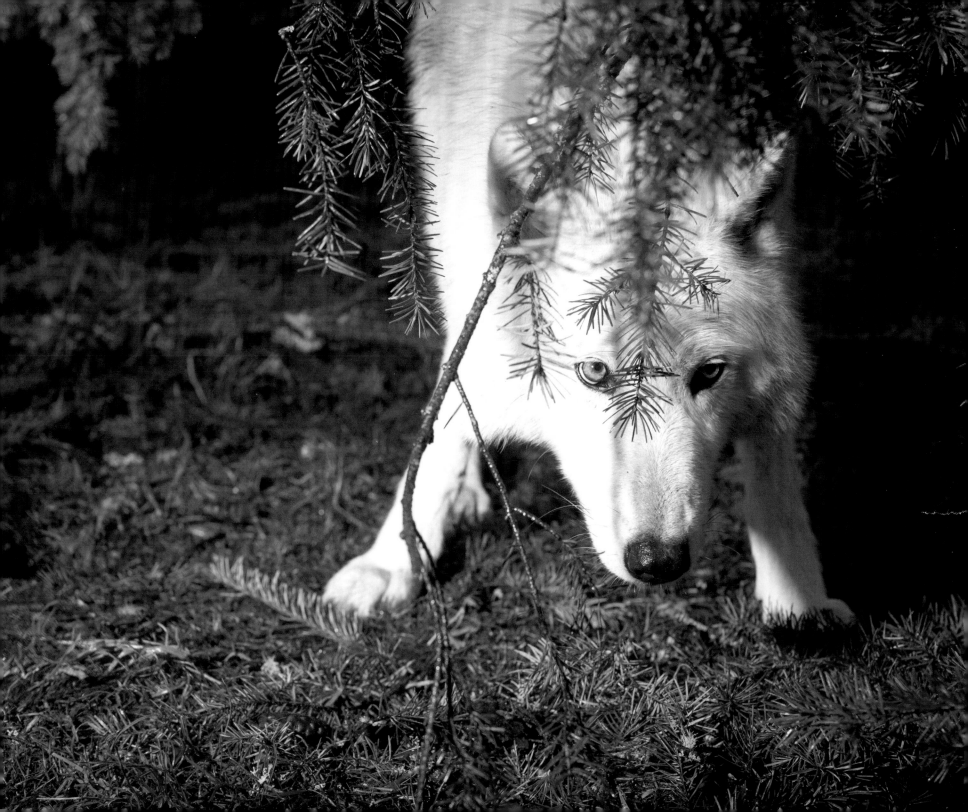

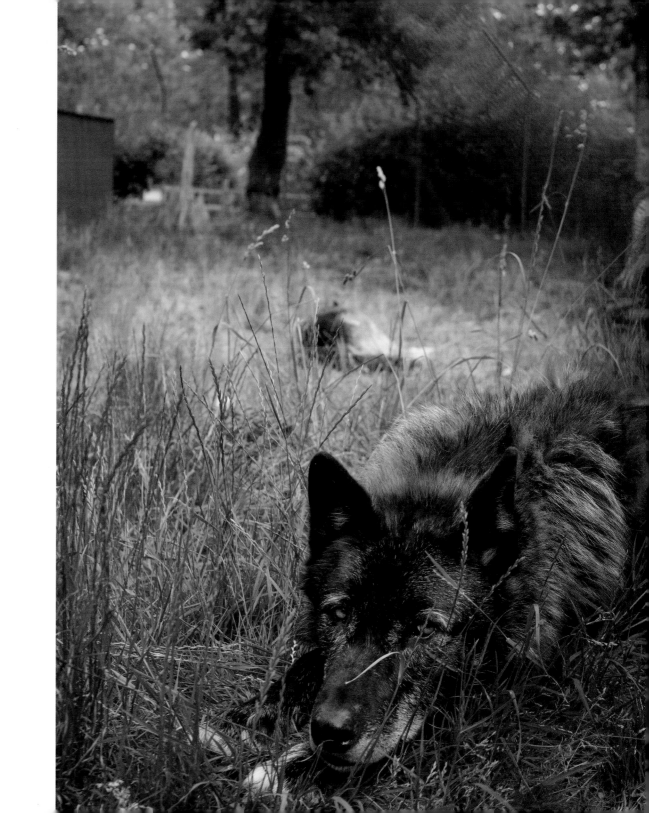

LEFT: *Meeka, a female wolf dog, is the shy partner of Lonnie.*

RIGHT: *Caedus resting with Ladyhawk in the background.*

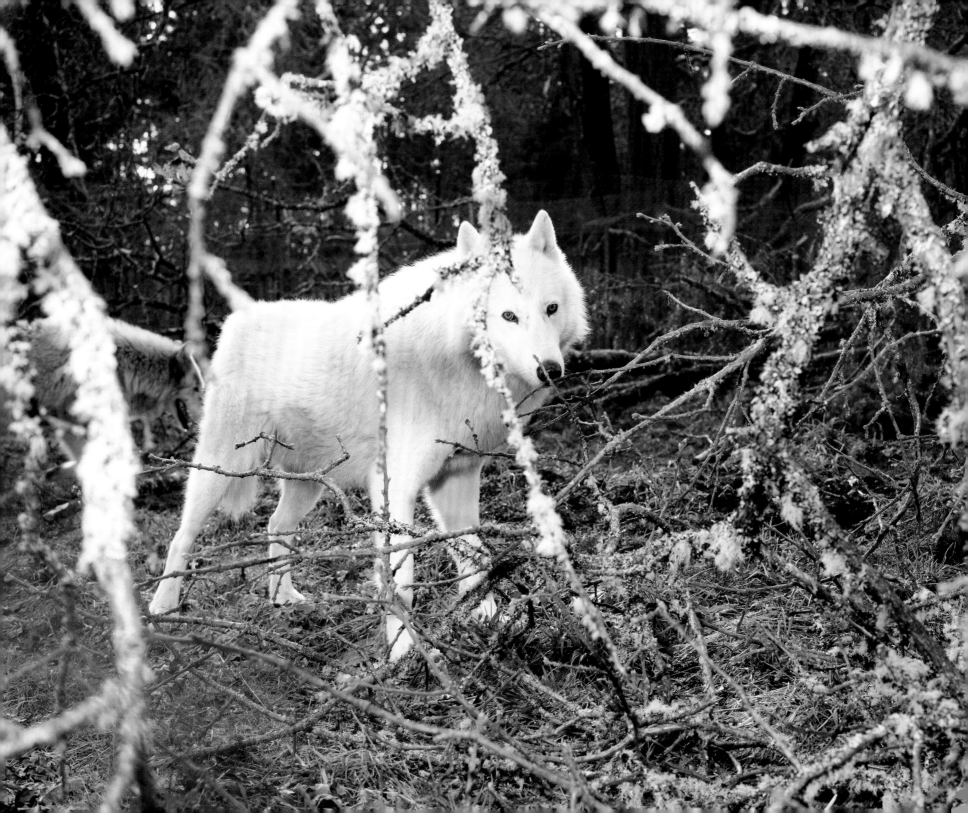

LEFT: *London, who came to Wolf Haven in 2009, amid the blowdown from a recent storm.*

RIGHT: *Wolves depend on eye contact*
for social relationships.

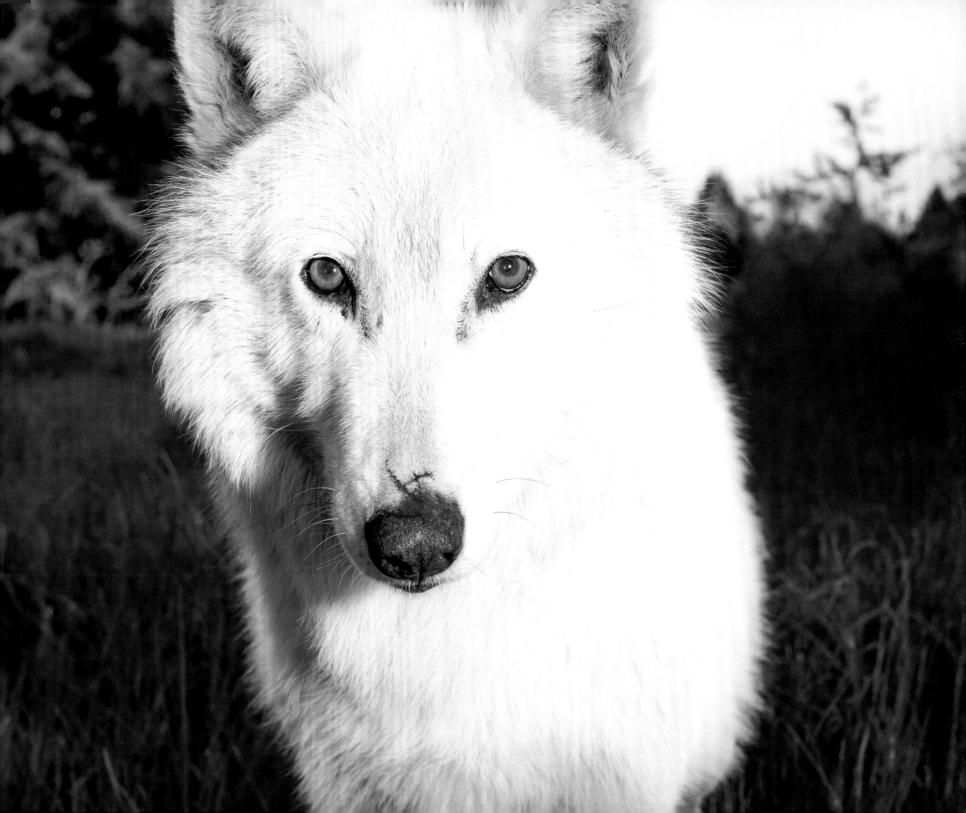

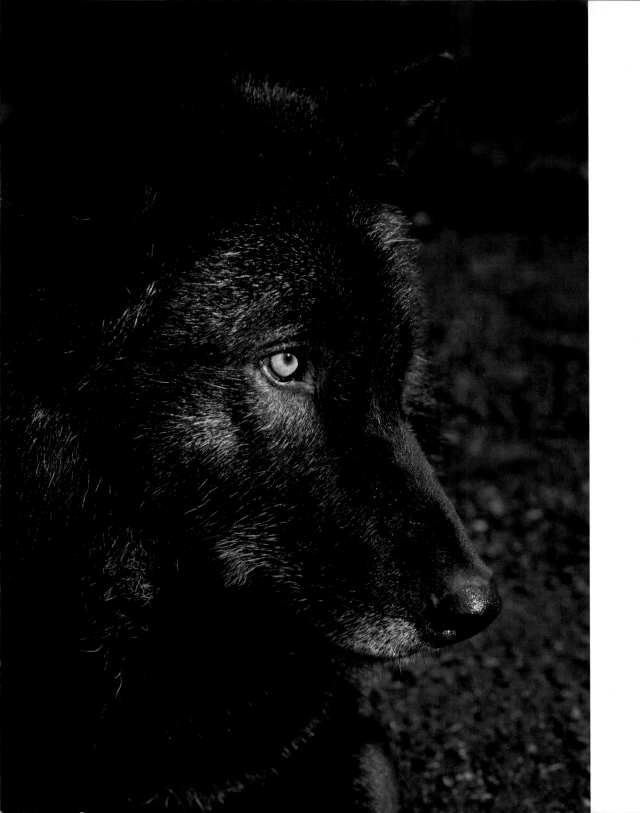

LEFT: *Caedus.*

RIGHT: *Lonnie amid storm debris.*

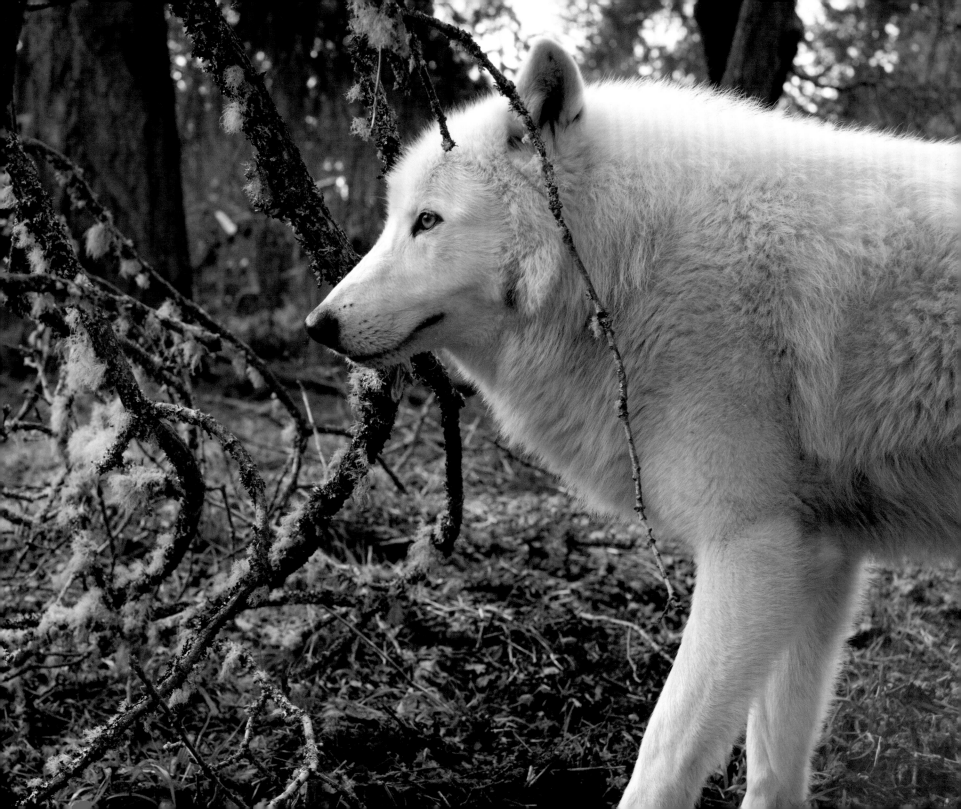

RIGHT: *Observant Shadow.*

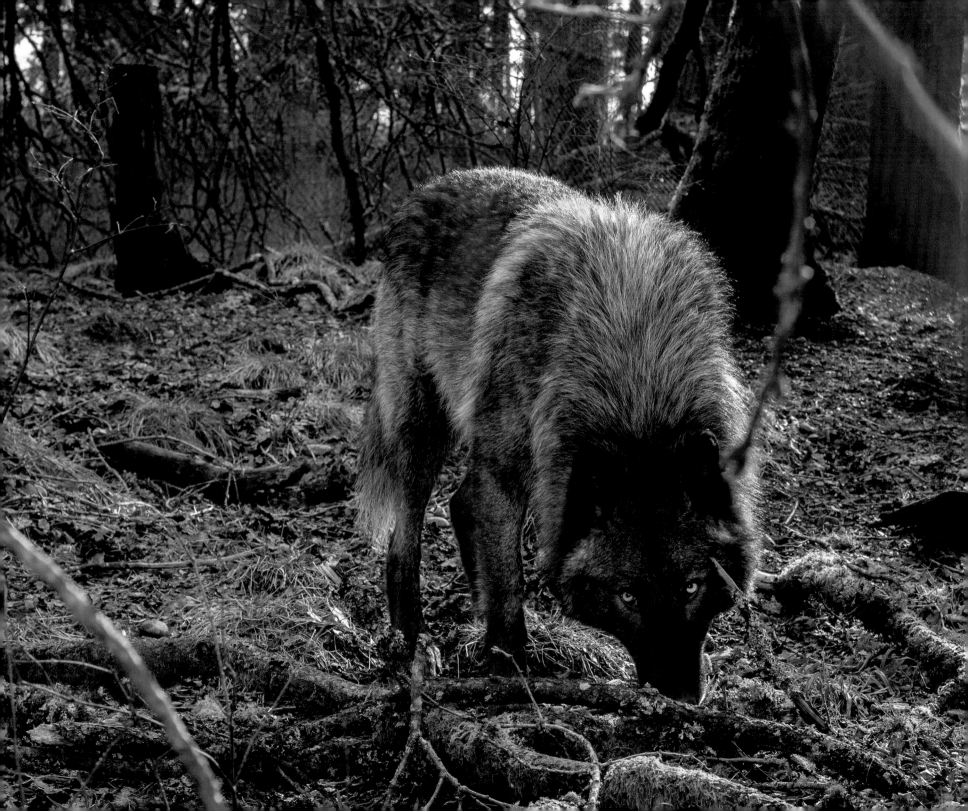

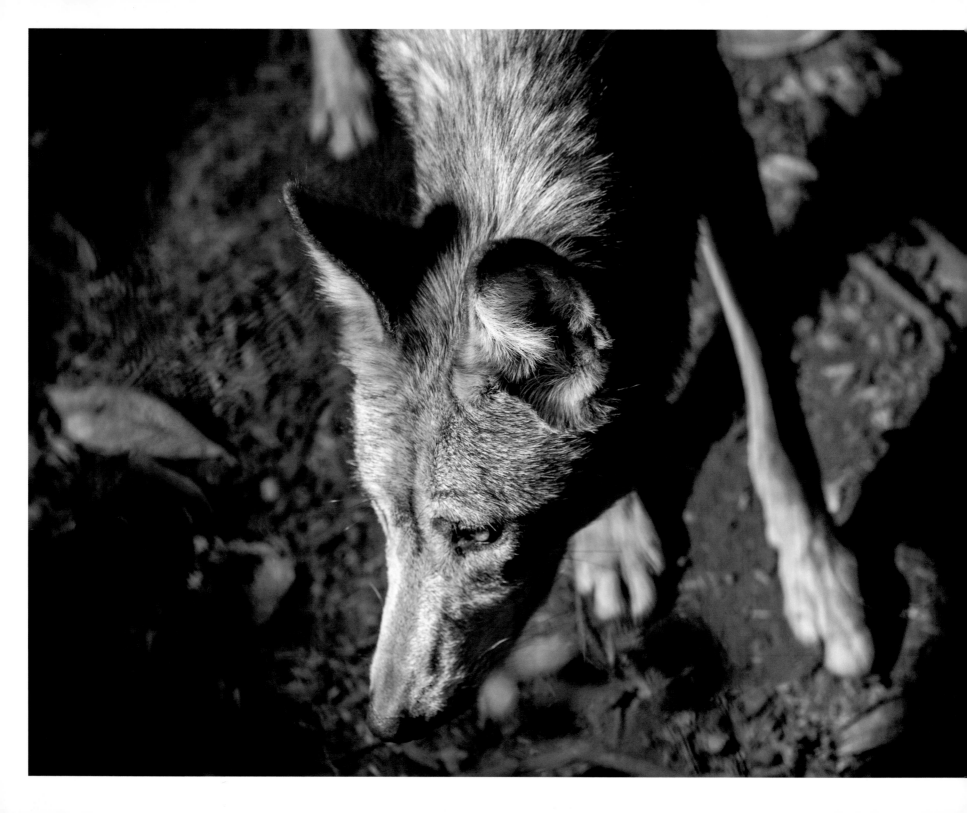

LOBO: BORN TO BE WILD

When we doom a species to extinction, do we have a responsibility to restore the animals again to their native habitat? Wolf Haven International and the fifty-two other facilities in the United States and Mexico are doing just that—returning captive-born populations of the highly endangered Mexican gray wolf (called *lobo*) to their birthright: the wild. It's a fragile but hopeful redemption for both people and wolves.

Once, over four thousand Mexican gray wolves claimed territory throughout the Southwest. Elegant and quick, the Mexican wolf is smaller than other wolf species, but this subspecies is equally strong, with the impressive stamina that comes from roaming vast mountains and high deserts. Yet this defiant survivor couldn't endure the relentless war against the wolf waged by ranchers, rangers, and federal trappers in the Southwest (as in most of the Lower 48). Poison, jagged-tooth metal traps, shotguns, and wolf bounties of four or six dollars (offered even to ranch boys)—these were the weapons so brutally used against the Mexican wolf, pejoratively labeled a "pest." A popular tactic for wolf hunters was to kill all but one wolf pup in the den, then chain that surviving wolf, howling desperately for his family. When the family returned to rescue the pup, every one of them was ruthlessly gunned down. By the 1940s, two subspecies of

the Mexican gray wolf were extinct. There was only one subspecies left—
Canis lupus baileyi—and one wild family surviving in Mexico.

Flash forward to the 1970s, when the Endangered Species Act (ESA)
restored not only wildlife but also some sanity to this country's relationship
with wild wolves. By law, a much more enlightened US Fish and Wildlife
Service (USFWS) had to figure out how to fulfill the ESA and recover this
long lost lobo to the their former range. How to do this when the total
number of Mexican gray wolves in the world was only twenty-three in
captivity, with just another handful struggling to hang on in the wild in
Mexico? The population of Mexican gray wolves in the United States was
zero. The US Fish and Wildlife Service faced some difficult questions: How
to bring this "essential" wolf back from the dead? How to convince cow-
boys and ranchers that their cattle could live alongside this top predator?
In the late 1970s the last five wild members of this threatened subspecies
were captured and moved to an emergency captive-breeding program—
giving birth, or rebirth, to the Mexican gray wolf. This vital program is
called the Mexican Wolf Species Survival Plan (MWSSP).

In 1994 Wolf Haven was selected to participate in the MWSSP, and
four Mexican wolves found safety at Wolf Haven. By 2008 five litters
of Mexican gray wolf pups were born at Wolf Haven. And then in 2015
ten Mexican wolf pups were born to three parent-pairs at Wolf Haven,
making eight total Mexican wolf litters born at Wolf Haven. In a rare con-
servation victory dozens of Mexican gray wolves have been successfully
released back into the wild.

Nineteen Mexican gray wolves live at Wolf Haven (eleven adults and
eight pups). Rare videos of the newborn Mexican gray wolf litter have
been captured by remote cameras. We watch the videos from these
hidden cameras of these new pups receiving their first medical exam.

PREVIOUS PAGE: *Moss, a male Mexican
gray wolf, was born at Wolf Haven in 2007.*

RIGHT: *Mexican gray wolves are highly
endangered. These pups are receiving
vaccinations.*

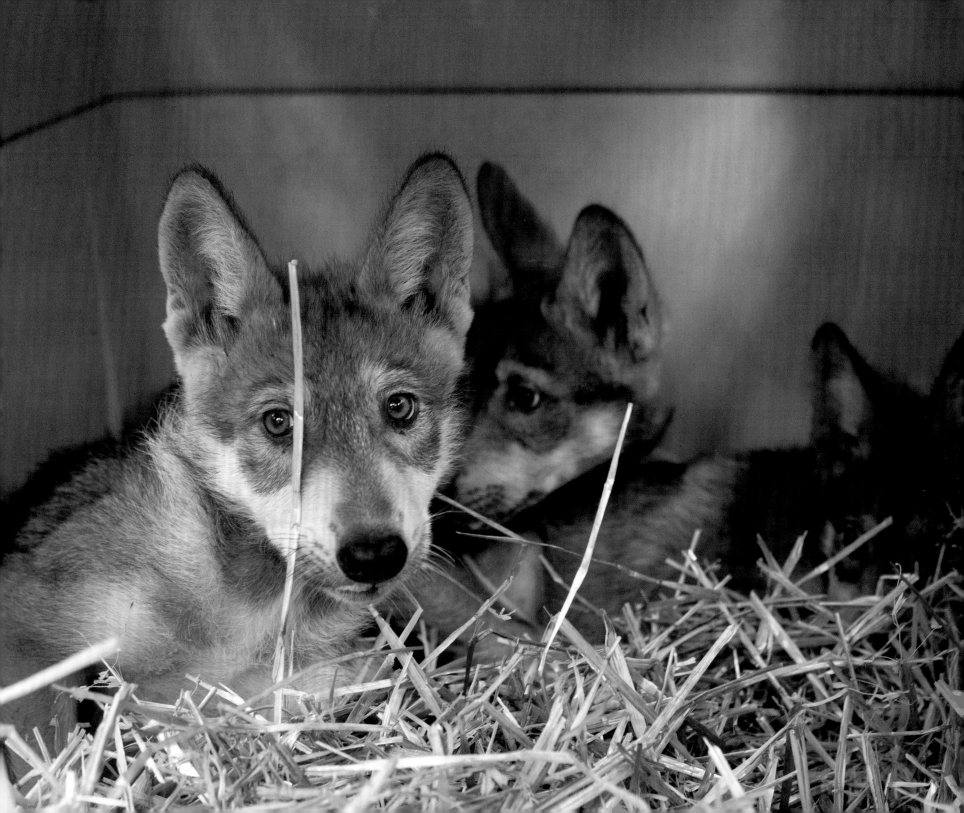

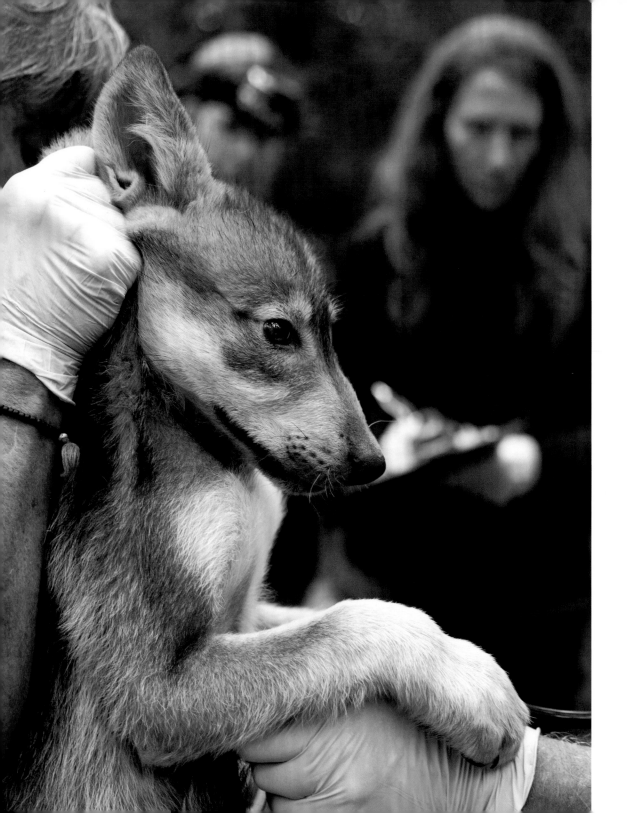

LEFT: *Mexican gray wolves only experience human contact at Wolf Haven during medical examinations.*

RIGHT: *Taking a health inventory of a Mexican gray wolf pup.*

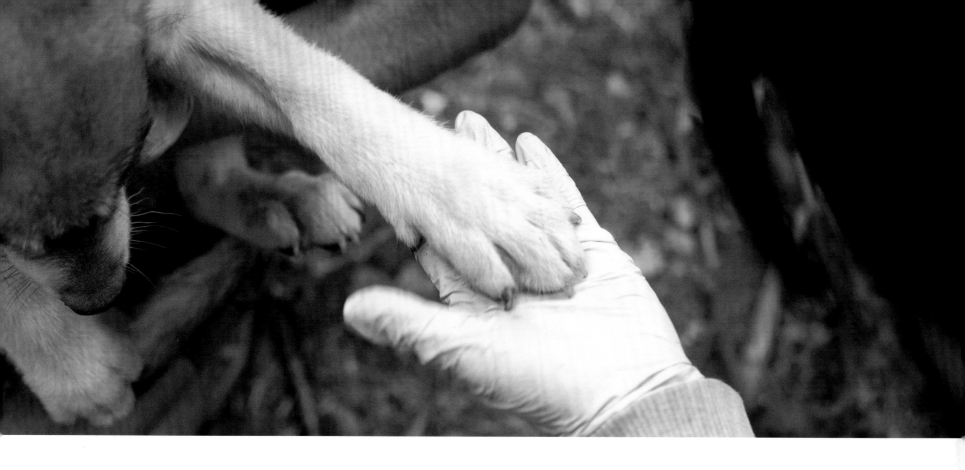

This six-week-old litter had never seen a human—until this morning. That's when Wendy Spencer crawls into their deep den to gently pull out the first pup. Tawny with wide hazel eyes, the tiny pup blinks at the shock of sunlight. All the Mexican wolf pup's senses are heightened in this first contact with humans. Silken, short baby whiskers twitch—trying to fathom this strange scent. Ears turn back in alarm.

Lifting the pup by his neck ruff of thick fur, Wendy balances him on her knees while the vet listens with a stethoscope to the rapid heartbeat. *Lub-dub, lub-dub, lub-dub, lub-dub!* Of course, the pup is frightened. Unlike the fairy tales of the Big Bad Wolf, wild wolves are intensely wary

of and avoid humans. In *The Predator Paradox*, wildlife researcher John Shivik suggests that to a wolf we humans smell like skunks. And wolves can "detect wafts of molecules on a gentle breeze and determine if a friend or foe approaches."

This Mexican wolf pup is among friends here at Wolf Haven. For his first physical exam, he is in very competent hands. The pup settles down as Mexican wolf specialist Pamela Maciel helps in the examination: checks vitals; measures height, weight, and length; administers necessary vaccinations. These new captive-born pups are critically important to the wild populations.

"Because the entire Mexican wolf population was founded by only seven animals, genetic diversity remains one of the biggest challenges to the health of this species," Maciel has stated.

All four pups in this litter are carefully examined and then released back into their den. That's where their parents, M1066 and F1199, welcome them home. Humans disappear like a fleeting dream. The family is together again to play. Only cameras will capture their daily lives over the next few weeks as they grow. Human contact will be extremely limited—only for exams.

"We want these endangered Mexican gray wolves to be as much like a wolf family as they can be," explains Diane Gallegos. "Every Mexican wolf pup born here is precious—and a potential candidate for release into the wild."

Born to be wild, I think watching the wolf family romp and roughhouse via the cameras. Will this be a litter given permission by USFWS to be reintroduced to their rightful habitat?

In my favorite video three Wolf Haven Mexican wolf pups roll and leap over their very laid-back father, who patiently endures their antics. This glimpse into the play of wolf parents with their pups shows their real

RIGHT: *Mexican gray wolf pup wearing a trial radio collar.*

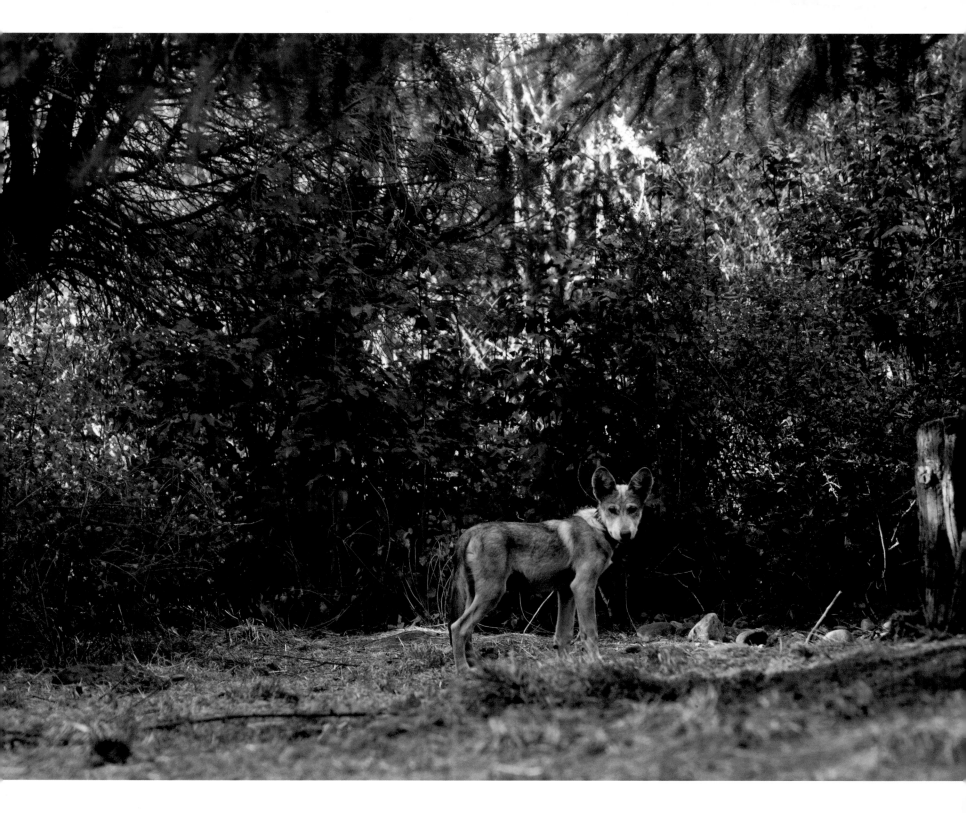

LEFT: *Wolf fur is dense and luxurious.*

RIGHT: *Bulletin board belonging to Pam, a biologist from Mexico, who is part of the animal care staff.*

lives: *The Big, Good Wolf.* Fond and attentive, the father of these pups will often regurgitate to feed his mate and newborns.

"Breeding pairs teach the young to maintain and assure the survival of the family," notes Yellowstone wolf biologist Rick McIntyre in a 1995 interview. A 2015 *New York Times* interview, "Tapping Your Inner Wolf," updates the stereotype of a dominant and aggressive alpha male wolf: in real life, notes McIntyre, alpha male wolves embody "a quiet confidence, quiet self-assurance . . . a calming effect."

At Wolf Haven, the Mexican gray wolves' parental tolerance models these tight-knit bonds of wild wolves. It's *all* about family. Suddenly the wolf family hears a strong, resonant howl from another wolf in the distance. All three pups jump up from their father's belly and trot toward the

echoing sound, their little ears pricked. They seem both bewildered and curious. A fourth pup scampers out of the bushes, and the entire litter huddles beneath their father's long legs as if for protection. Then they dash into the trees to hide until their mother joins the group. The pups rejoin their family. Only then does the father raise his head to howl—a long, steady, and strangely melodic wolf song. His voice modulates from high to low, which sets off nearby resident coyotes to join in with their high-pitched yip-yip-yipping. The mother wolf joins her mate in the howl as his voice rises into a withheld, haunting key—one I recognize as C# from my years of singing. At last, the wolves shift chords to B major and their voices die out.

But not their species. Please, not this deeply endangered species.

Wolf Haven is working diligently to help save the Mexican gray wolf and safeguard these three litters born in the spring of 2015. One of these wolf families has just been selected for reintroduction to their native habitat in Mexico. Lobos go home!

One definition of the word *wild* is *self-willed*. Will this wolf family soon forget the time when fences and humans held them? Soon these wolf pups, born to be wild, will race across wildflower-flamed meadows with their siblings, testing their hunting strength against an elk herd. It will only take them a few weeks to remember how to be wild wolves once again.

Though these captive-bred wolf pups are nurtured here in the Northwest, their future is the verdant valleys and remote plains of the Southwest. In 1998 a coalition of agencies, including Arizona Game and Fish Department, the USFWS, the US Forest Service, the USDA Animal and Plant Health Inspection Service, and the White Mountain Apache Tribe, worked together to attempt Mexican wolf recovery. Their goal was a self-sustaining group of a hundred wolves by 2006. It would take

RIGHT: *The Mexican gray wolf is the smallest of the species.*

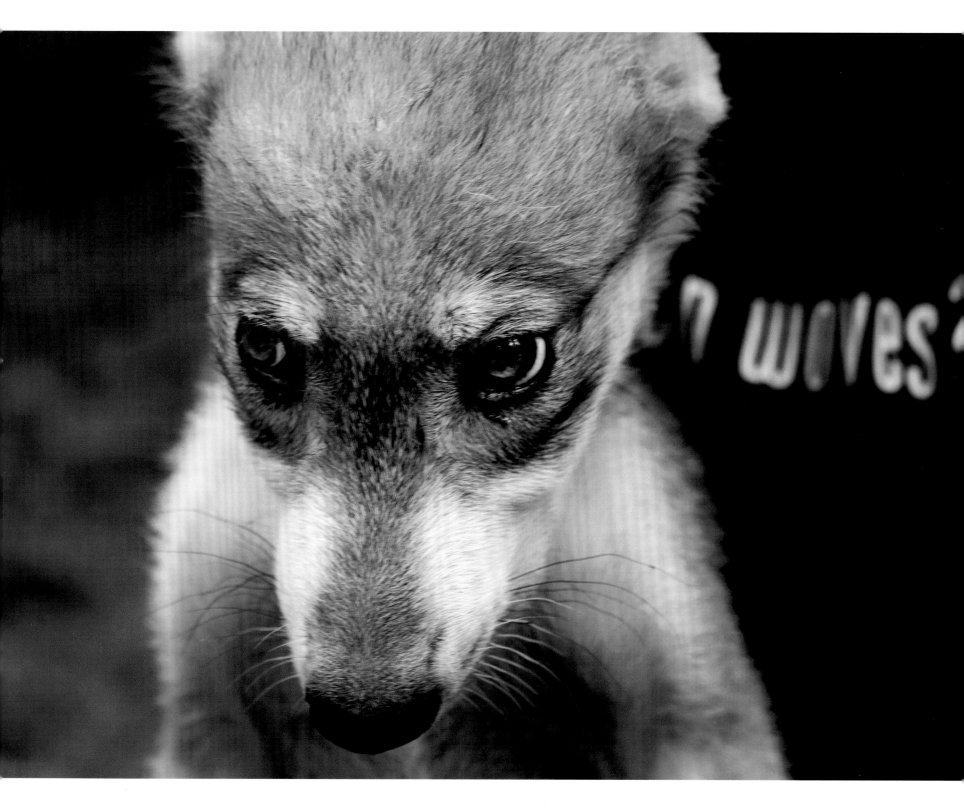

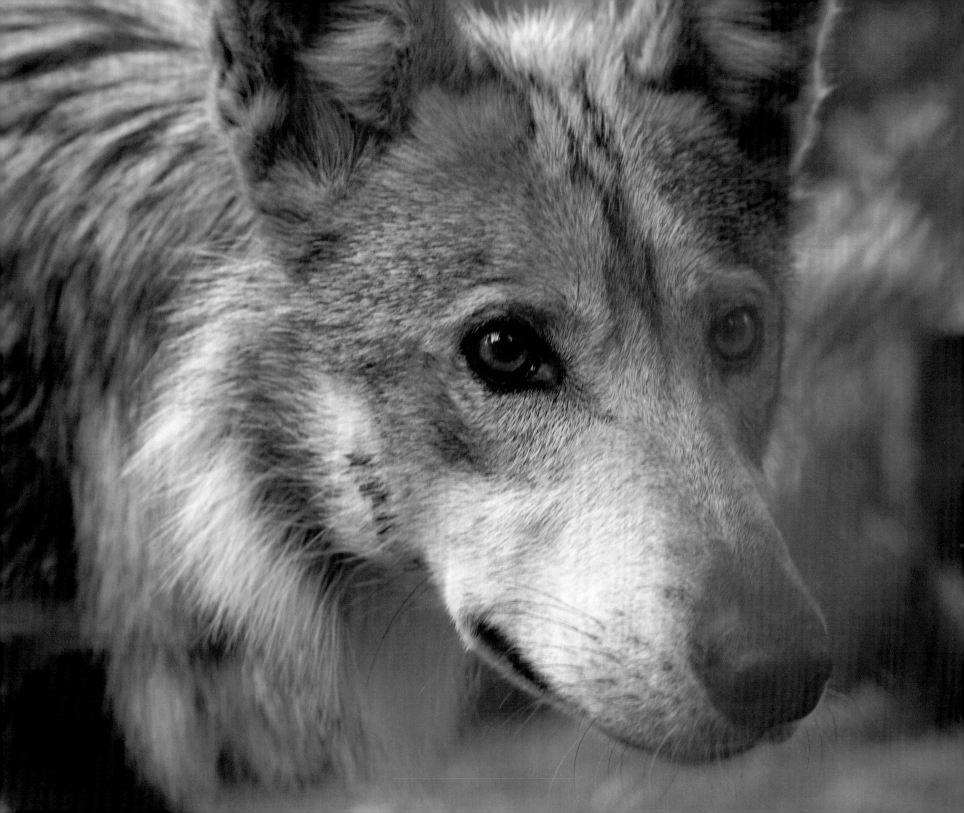

until 2014 before the Mexican gray wolf population came even close to that number.

In 2014 there were 109 wolves in the wild, a 31 percent increase over past years. In 2015 the USFWS reclassified Mexican gray wolves as an "endangered subspecies" and a "nonessential, experimental" population. This gives Mexican gray wolves somewhat more protection, especially since the rules governing recovery and range have changed: from a goal of 100 wolves allowed to 325, and their territory is extended from 7,000 square miles to 150,000 square miles. This news for Mexican gray wolves is somewhat tempered by the fact that unlike most species listed as endangered, a Mexican gray wolf may still be legally exterminated if discovered killing, wounding, or biting domestic livestock or pets on federal or private land. Mexican gray wolves can also be shot if they create "unacceptable impacts" to the deer and other game animals for hunters.

Many wildlife watchdog groups argue that these new rules don't go far enough to ensure the wild Mexican gray wolf will rebound to be a viable, self-sustaining species. The issue is how many wolves are really needed for a healthy and genetically diverse population. In 2011 a scientific panel estimated that at least "750 wolves in three distinct population areas, connected by corridors" is the real target for viable Mexican wolf recovery.

"There's only one wild population," argues Judy Calman with the New Mexico Wilderness Alliance. "So losing the one wild population would mean there are no more wild ones."

That's why a coalition of wildlife groups, including Friends of Animals, filed a suit the same summer the Wolf Haven Mexican pup litters were born. The lawsuit asks the USFWS to list the Mexican gray wolf as "essential" and asks that science, and not politics, guide the feds in fully restoring this species and giving lobo a "fair chance for a real future."

LEFT: *Moss, father of the one of the litters of Mexican gray wolf pups born in 2015.*

"As it stands today, there are no excess Mexican wolves," notes Friends of Animals president Priscilla Feral. She urges the USFWS to revisit the lethal "take" provisions and use the best science to truly conserve this species.

The federal plans for releasing more Mexican gray wolves into the Southwest has recently been thwarted by state resistance from New Mexico and Arizona wildlife commissions—even though there is strong public support for wolf recovery in these states. In the fall of 2015 USFWS overrode the New Mexico Department of Game and Fish's rejection of increased Mexican wolf reintroduction. The federal government will continue to support the reintroduction program to assure much-needed genetic diversity in this critically endangered population.

In all the Southwest political battles there is a bright note from Mexico where one litter of pups born into the wild is still alive. Wolf Haven's magazine, *Wolf Tracks*, notes: "This is the first time a Mexican wolf family has survived for a year in the wild, and the second litter of pups born into the wild since they were exterminated in the late 1980s."

As the fate of Mexican gray wolves in the wild plays out in state politics and the federal courts, the little lobos at Wolf Haven are also playing—not without some losses. One morning, when Wendy crawled into the den, she discovered to her dismay that two of the little pups had died from parvo, a virus especially fatal to puppies—both wild and domestic. Only one very sick female wolf pup still precariously clung to life.

That female pup was nursed back to health by the Wolf Haven staff and now is growing strong and healthy.

"We've just heard that another Wolf Haven Mexican gray wolf family will be the next Mexican wolves released into the wild," Diane told us on another late summer visit. She reminded us with a note of pride that Wolf Haven "had so much success with our captive-breeding Species

RIGHT: *Mexican gray wolf pup quietly passing time.*

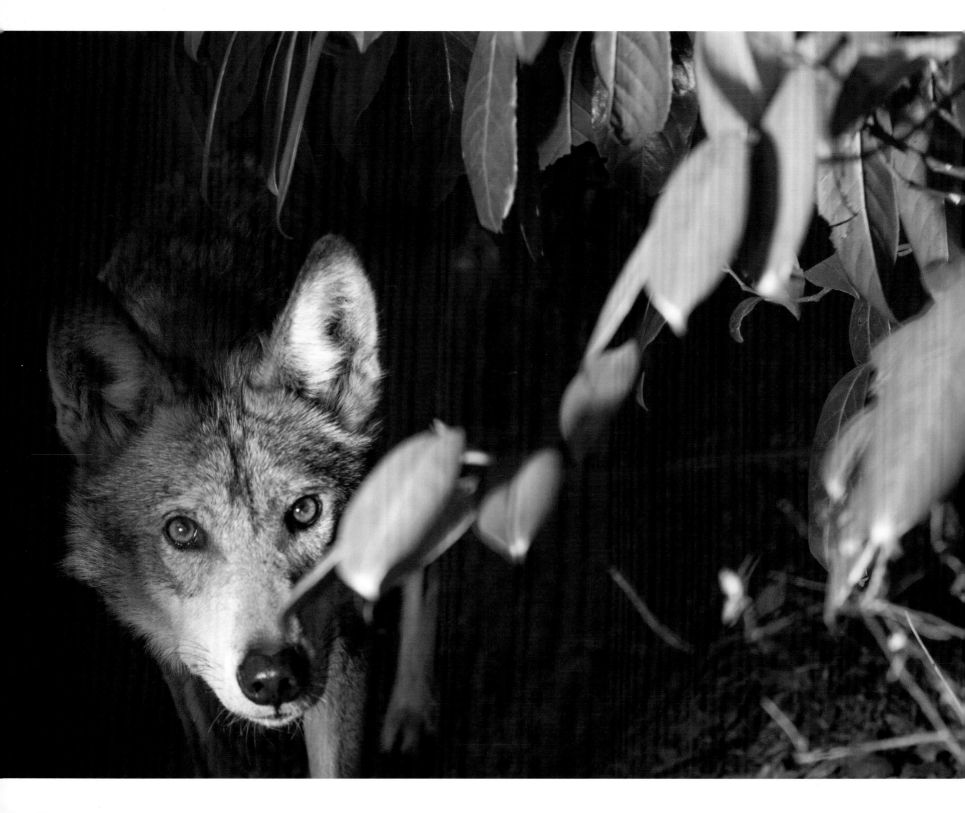

Survival Program. The Hawk's Nest family from Wolf Haven was the very first group to be released into the wild."

Lobo was the very first Old World wolf to enter the United States, crossing the Bering Land Bridge during the Pleistocene Era. In this twenty-first century, as we temper our extinction mistakes and envision a more balanced and shared ecosystem, can we learn from lobo?

Watching these growing Mexican wolf pups leap and jaw wrestle with one another, it's tempting to hope that this smallest of wolves might have a huge effect on both our habitat and our hearts.

These are the wolves that inspired Ernest Thompson Seton, one of the founders of the Boy Scouts of America, to fervently champion the wild wolf all his life. In the 1890s, after trapping and killing a majestic Mexican wolf (later named Lobo), his whole family, and his mate (Blanca), Seton wrote: "Ever since Lobo, my sincerest wish has been to impress upon people that each of our native wild creatures is in itself a precious heritage that we have no right to destroy or put beyond the reach of our children."

These Mexican gray wolves also radically changed the mind of a young US Forest Service employee, Aldo Leopold, on the Apache National Forest whose early work included killing bears, mountain lions, and wolves. When Leopold watched a family of wolf pups join together in a "welcoming melee of wagging tails and playful maulings," he and his friends were young "and full of trigger-itch" and "had never heard of passing up a chance to kill a wolf. In a second [they] were pumping lead into the pack."

When their rifles were empty, one old female wolf was down and one pup dragging a wounded leg limped off into the rocks. As Leopold witnessed the "fierce, green fire dying" in the old wolf's eyes, he had a revelation that forever changed him and our conservation ethics. "There was something new to me in those eyes," Leopold writes in his famous

LEFT: *Male Mexican gray wolves are known as* el lobo.

"Thinking Like a Mountain" essay. "Something known only to her and to the mountain."

Aldo Leopold recognized an undeniable truth in that wolf matriarch's bright burning eyes. She, like so many other wolves, was sacrificed to our slaughter of any animal who dares to *not* be domesticated, to *not* be in service to our needs, to be instead *self-willed*. Wild. Leopold and many more wildlife advocates since him have realized that we lose something wild in ourselves when we kill off these fellow creatures and claim their territory only for ourselves. When we return this Mexican gray wolf from the dead and restore these endangered families to their native homes, we also resurrect, re-wild, and reunite with a long-lost part of ourselves. That's the enduring gift of *el lobo*.

RIGHT: *Mexican gray wolf pup heading back to the enclosure after receiving vaccinations.*

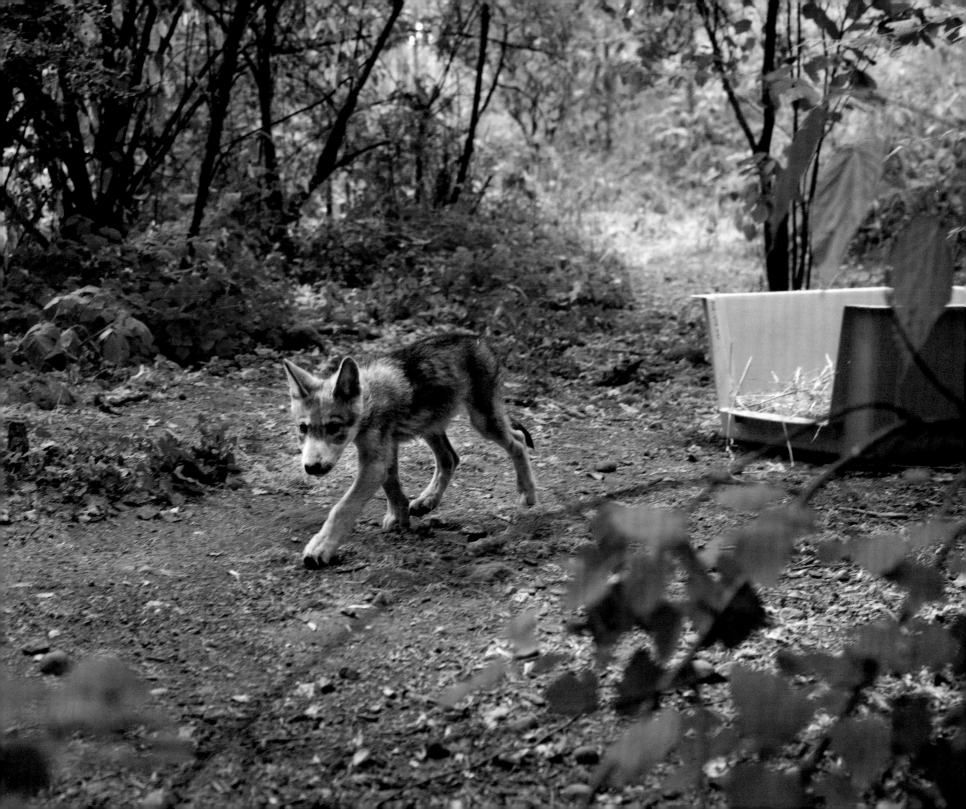

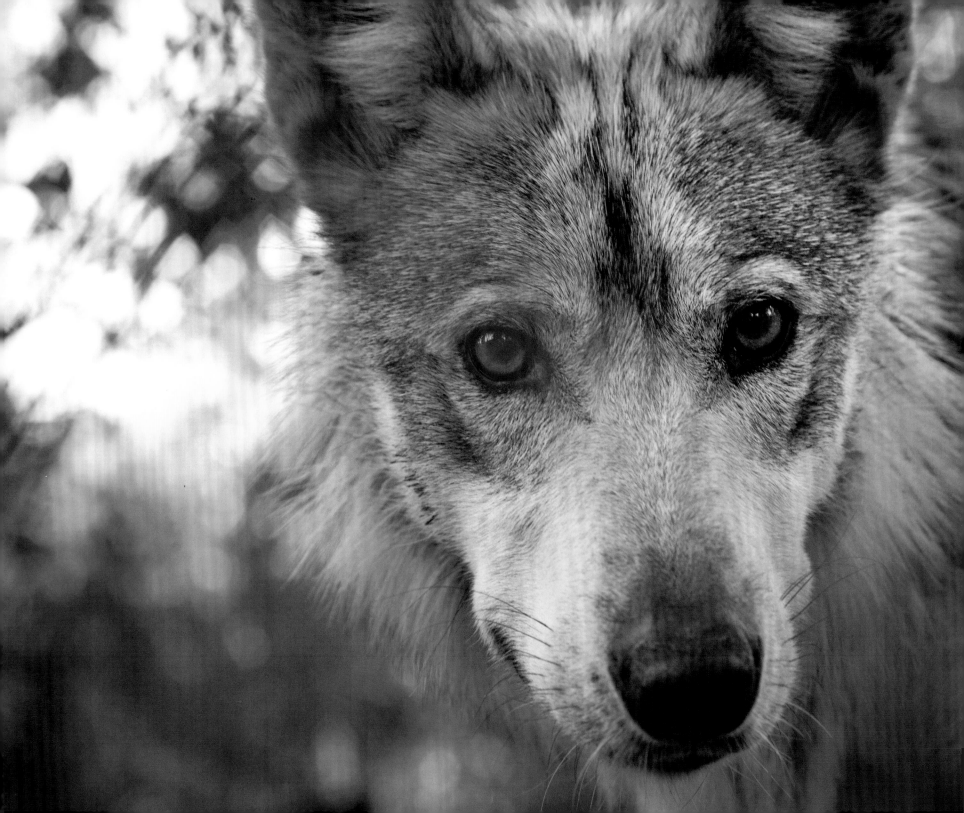

LEFT: *Moss.*

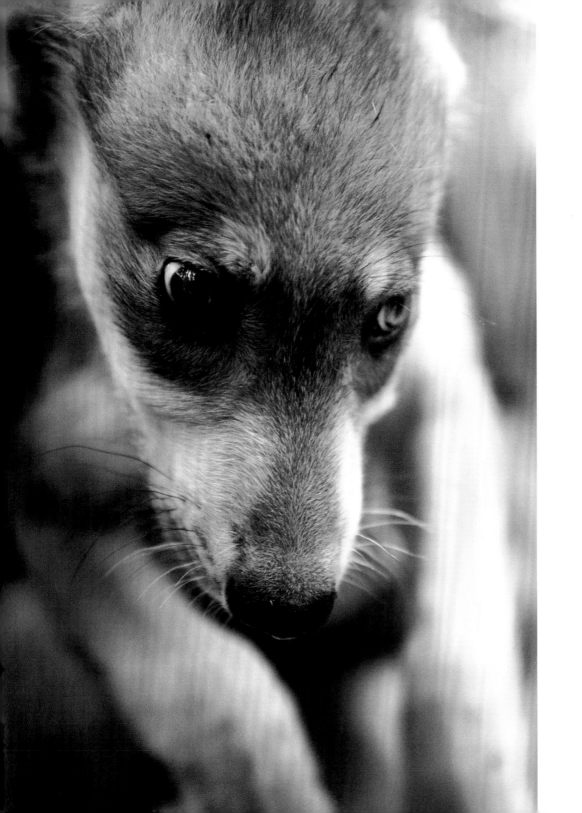

LEFT: *This Mexican gray wolf pup may return to the wild.*

RIGHT: *Lorenzo.*

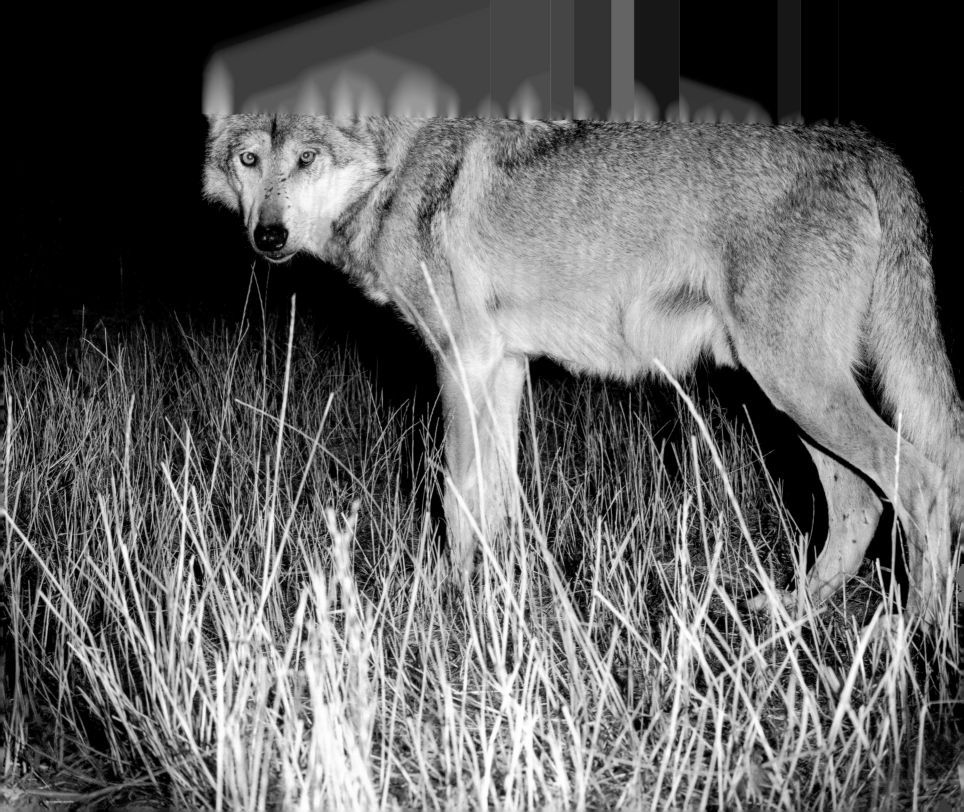

RIGHT: *Wolves are keystone species, and when returned to the wild, they help restore the entire ecosystem.*

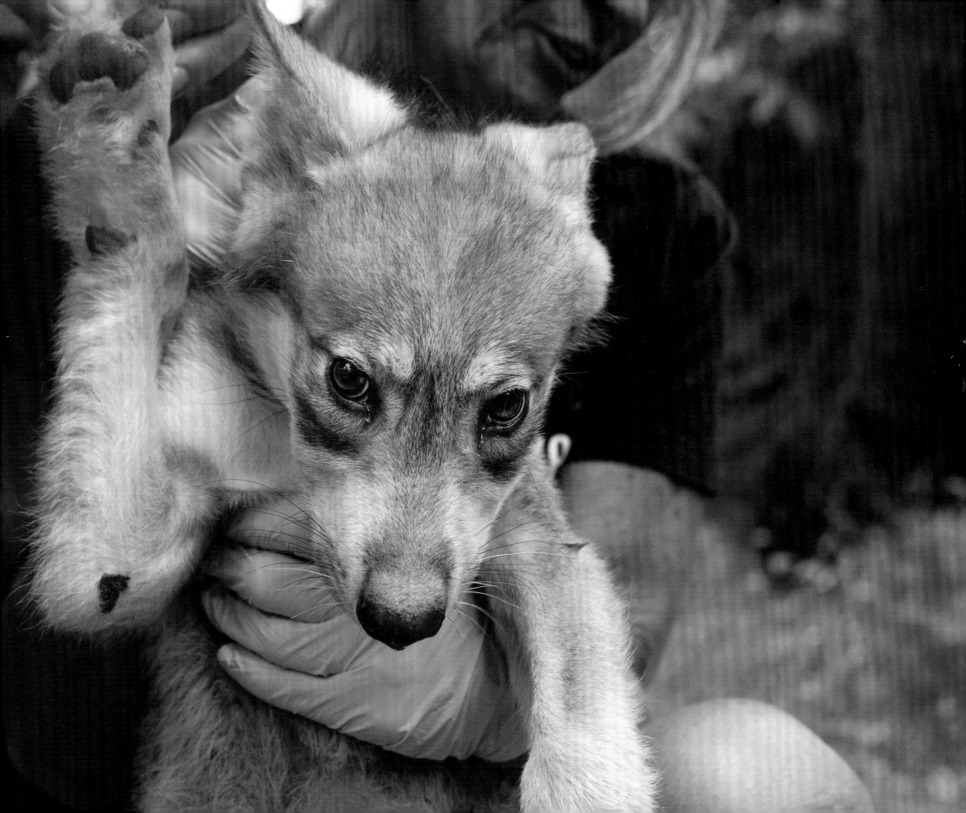

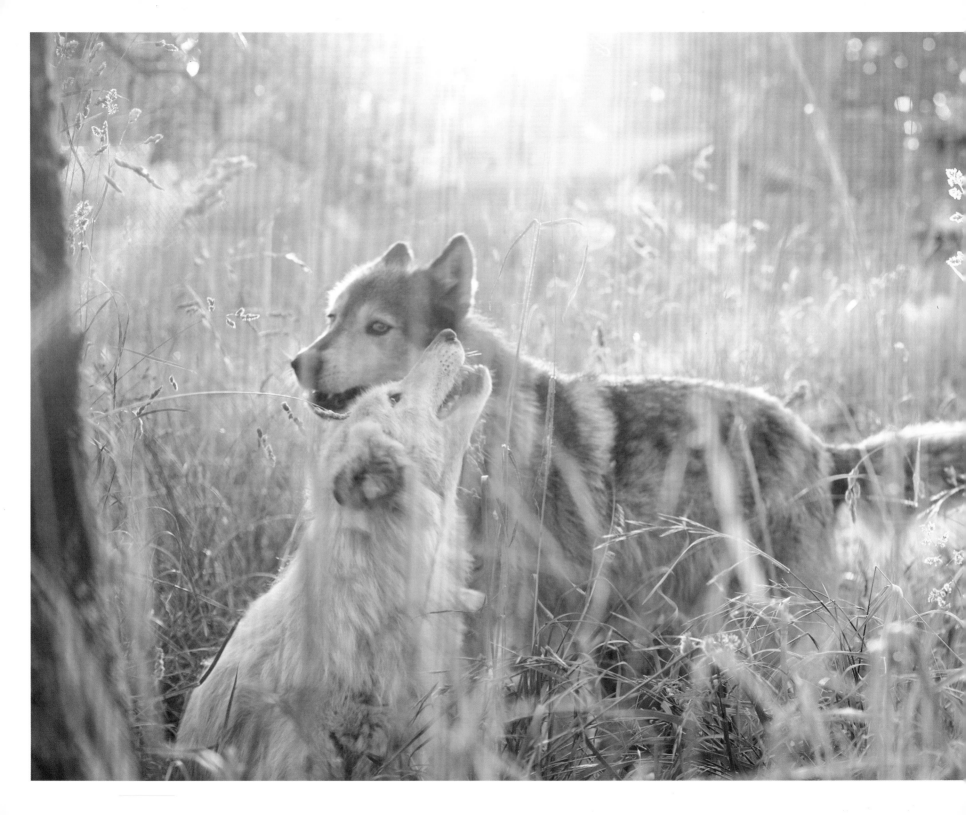

THE WOLF AND THE WEST: "ROOM FOR ALL OF US"

We walk through the sanctuary's "mounded" prairie of pale, sibilant grasses. Each spring Wolf Haven International is so brightly lit with purple camas lily, golden paintbrush, early blue violet wildflowers, shooting stars, and buttercups that it's like drifting through a living watercolor canvas. These native flowers attract many essential honeybees and butterflies, such as the extremely rare valley silverspot. Wolf Haven is also vibrant with native fauna and sounds—the shy skitter of jackrabbits, the percussive calls of the chorus frog, and the cheerful *chup-cup* of the western bluebird. Everywhere we amble the land is alive and healing, the very definition of sanctuary—"haven, refuge, shelter in times of trouble."

"See those little yellow flags scattered through the prairie?" Diane Gallegos asks. "Those are the research flags for the Washington Department of Fish and Wildlife (WDFW). They're researching the highly endangered and important Mazama pocket gopher who is returning here. Wolf Haven is all about restoration."

Wandering through these summer grasses haloed in strong sunlight is like traveling back in time to another century—when these preserved forests and restored prairies were not just an eighty-two-acre refuge

but the rightful habitat of wild wolves. Imagine these wolves unfettered by fences and roads, by ranches and shopping malls, by subdivisions or sprawling cities. Imagine our Lower 48, the native territory of what scientists estimate was once over two million wolves. For thousands of years Native tribes like the Quileute and Makah have told their enduring stories of wolves as "First People." Indigenous peoples, still today, apprentice themselves in learning the collective hunting skills, self-regulating societies, and tribal loyalties of wolf families. Their native songs, dances, and stories always celebrate Wolf as spirit guide, family member, and mentor.

The late Quileute tribal elder, Fred Woodruff, once told me on a research trip for my National Geographic book, *Sightings*, on gray whales. "Our tribe originally descended from the Wolf Clan. We believe they are our relatives and are always welcome in our land. We learned from the wolf how to survive and how to be more human. How to honor our elders, to protect and provide for our families—and we learned the loyalty you need to really belong to a tribe."

This profound respect and reverence for wolves is echoed throughout Native American culture. But European settlers, as they conquered this vast continent, saw the wild wolf as a "nuisance" or "pest" to be exterminated. After five hundred years of European development, there were only about five to fifteen hundred wolves left in all of the Lower 48.

As if in memorial we quietly stroll now past the delicate Wolf Haven totem poles carved with wolves and then past the cemetery and elegant gravestones honoring those wolves who have passed on—Riley, Cherokee, Jessie Jones, Shiloh, Denali, and so many others—memorialized in small plaques, each with a poignant wolf portrait. At last we arrive at a gigantic cedar—the "Grandfather Tree." Gnarled and ancient, the Grandfather Tree offers us calm shade as we rest from the heat. Nearby, the wolves are resting too, sheltered by dense and protective trees, their forever forest.

PREVIOUS PAGE: *Jesse James (left) and her devoted partner, Shiloh.*

RIGHT: *Juvenile cottontail in the sanctuary.*

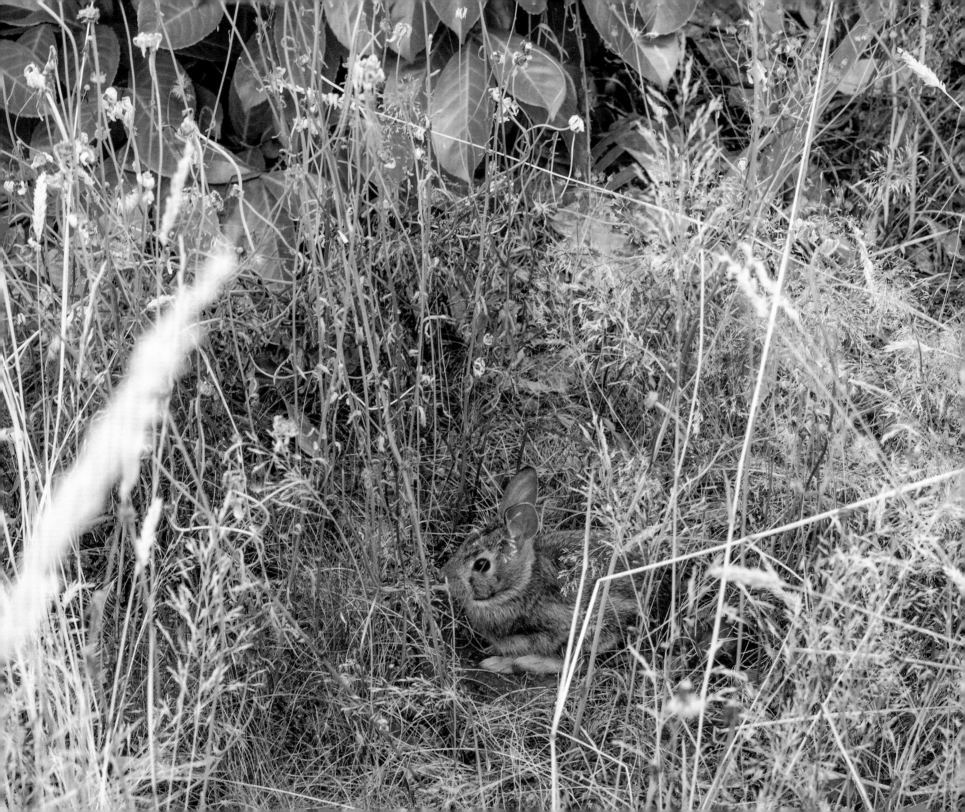

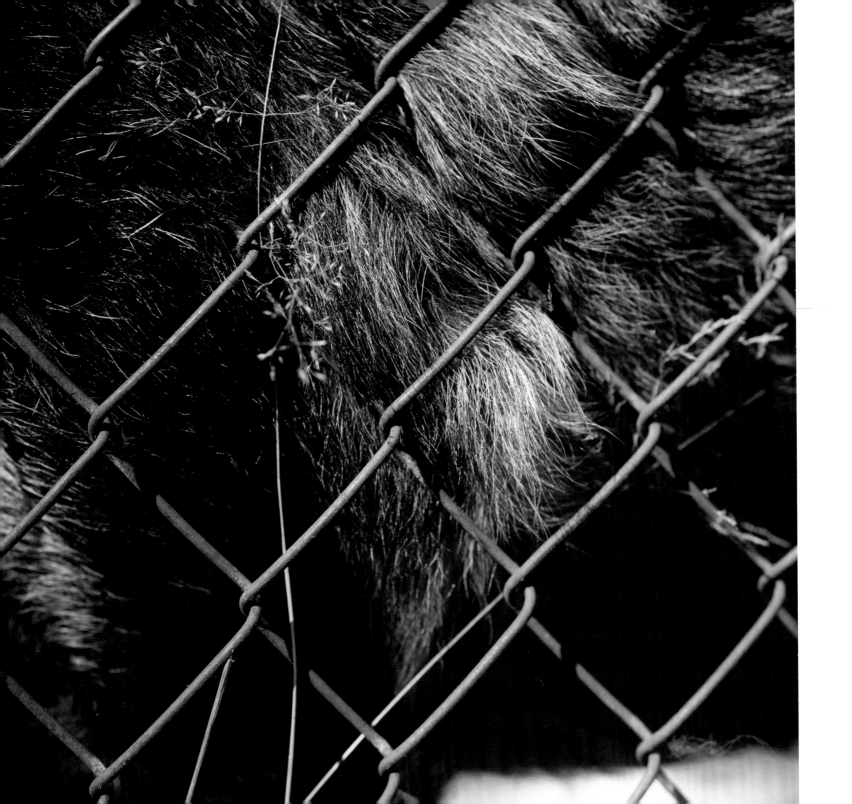

I lean against the Grandfather Tree, its straight and sturdy red bark like another spine to support me. Finding shelter here in the generous shade of the Grandfather Tree, birdsong above us, cool forest floor beneath us, I place my palm on the rich, craggy red bark of this ancient cedar and close my eyes, listening. Soft, warm wind sings through the embracing branches. A squirrel chitters, and in the distance, a wolf raises her primal call to reunion. She may have left the wild, but the memory of the wild has never left her—or us.

LEFT: *Wolves have gray underfur.*

RIGHT: *Sanctuary bees.*

Our stories can destroy or save a species.

In the twenty-first century there is a new story being told about wolves that is based not on prejudice and fear, but on real knowledge and scientific insights into how vital the wolf is to our ecosystem's and our own survival. In the 1960s the environmental movement took root. Inspired by Rachel Carson's *Silent Spring*, new voices and visions emerged, based on a more holistic, "deep ecology" science. By 1995 when wolves had dwindled down to unsustainable populations in much of the Lower 48, the USFWS at last began to listen to these new stories and fulfill Aldo Leopold's dream of reintroducing wild wolves.

In the winter of 1995, I stood on a hillside in Yellowstone's Lamar Valley with other journalists to witness the return of wild wolves to the park. Through telescopes we watched, riveted, as the original Crystal Creek wolf family romped and ran with their playful pups. "They're the first wolves born here in seventy years," whispered veteran wolf biologist Rick McIntyre with obvious pride. "It's a big circle of life."

Every year since the wolf reintroduction, tourism has flourished as thousands of park visitors flock to Yellowstone in the hopes of witnessing wild wolves. Yellowstone wolves are considered the greatest conservation success story in US history. In Yellowstone scientists have documented that returning wolves, beaver, and vegetation to a degraded landscape helps restore the ecosystem to a more natural balance. Wolves keep elk populations from overgrazing so aspen, cottonwoods, and willow regenerate, which means stream banks are less eroded. Songbirds, beavers, and grizzly bears all benefit from the wolves' presence. John Varley, a Yellowstone official who for twelve years worked in wolf reintroduction, told the *Billings Gazette*, "The only thing that has really surprised me about wolves is how many other things they affect. The number of other creatures they feed is astounding."

RIGHT: *Jesse James.*

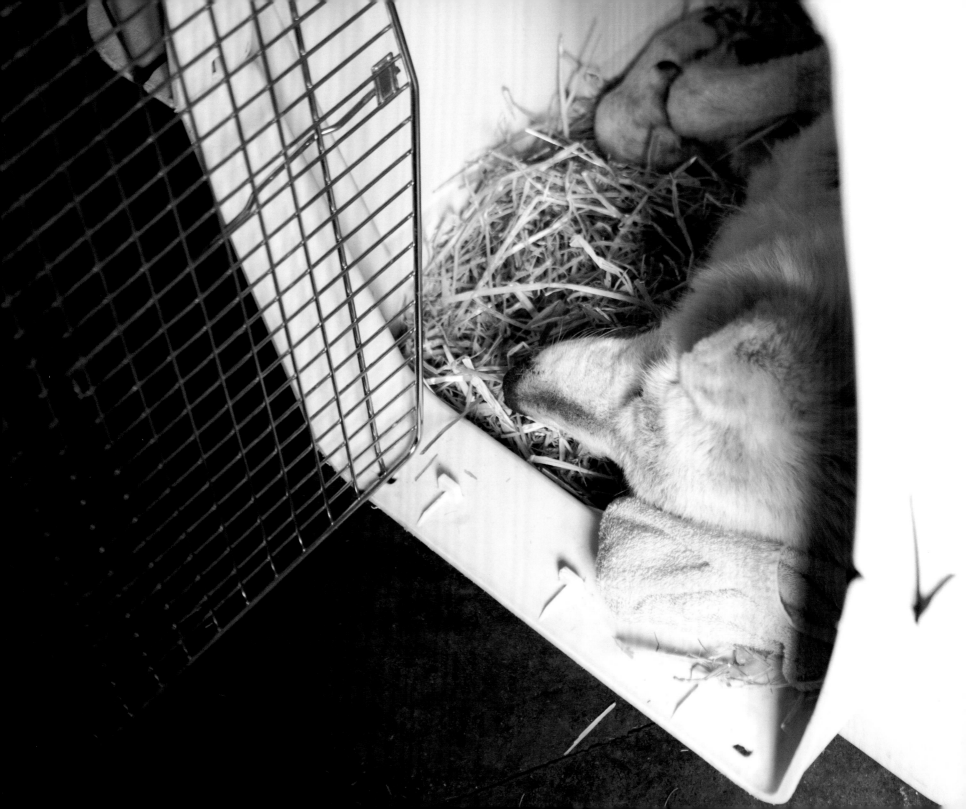

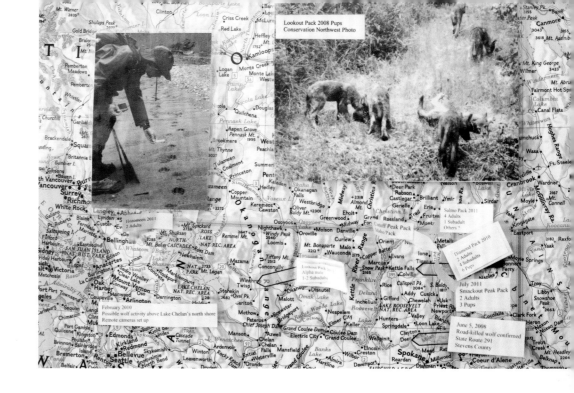

Lookout Pack 2008 Pups
Conservation Northwest Photo

Wolves also directly benefit humans. Science has finally proven what Native peoples always knew: wolves are our true partners and teachers. Wolf biologist and author Cristina Eisenberg echoes this in her groundbreaking book, *The Wolf's Tooth*: "To create healthier ecosystems, it makes great sense to conserve wolves. They still have so much to teach us about living more sustainably on this earth."

There is a new story being written here in the West that is more far-sighted, practical, and understanding about how much we need wild wolves to help balance our ecosystems. Washington, Oregon, and California are engaged in the very early stages of wolf recovery. Wolves are still on the endangered species lists in California and Washington.

LEFT: *Jesse James returns from the vet*.

RIGHT: *Sanctuary map*.

To recover in Washington they need fifteen breeding pairs, four in each of three diverse regions and three anywhere else in the state. In the summer of 2015 there were only five breeding pairs out of sixteen known groups—sixty-eight wolves total.

"Washington has the best wolf management plan in the West," says Conservation Northwest's Mitchell Friedman. "Thinking differently is good not just for wolves, but for ranchers and residents, as well."

Can Washington now manage its wolf reintroduction more sustainably than other states, like Wyoming, Idaho, and Montana, where loss of federal protection for wolves in 2012 has again triggered unsustainable wolf hunts? Leaving wolf management to the states was driven by politics not science. In several Rocky Mountain states without federal protection, wolf management has again regressed to wolf extermination. Since the 2012 delisting, Idaho state wildlife officials immediately returned to wolf hunts without waiting the usual five years post-delisting to make sure the species was sustainable. Idaho governor Butch Otter's new predator control plan aims to kill up to 60 percent of wolves. In 2014, Idaho's Department of Fish and Game shot twenty-three gray wolves from a helicopter near the Idaho-Montana border with the stated intent to boost elk harvests for game hunters.

Other Rocky Mountain states have reverted to similar anti-wolf prejudices, which allowed wolves to be killed anytime, anywhere. In 2014 a successful lawsuit filed by Natural Resources Defense Council (NRDC), Earthjustice, and Defenders of Wildlife put a temporary halt to this rampant wolf hunting and restored federal protections to wolves in Wyoming and across the Great Lakes. But in the 2016 US Congress, there are new legislative initiatives to strip wolves and other top predators of these restored protections and gut the Endangered Species Act. The war against the wolf has reignited and still rages on in these states.

RIGHT: *Riley makes a rare appearance.*

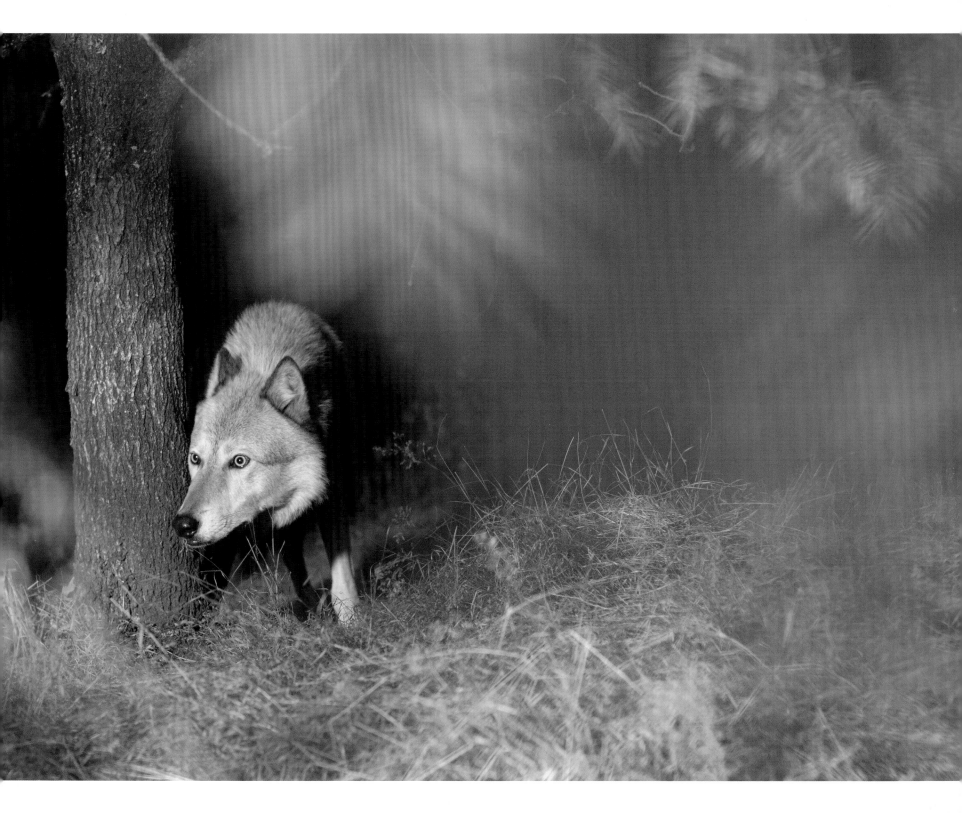

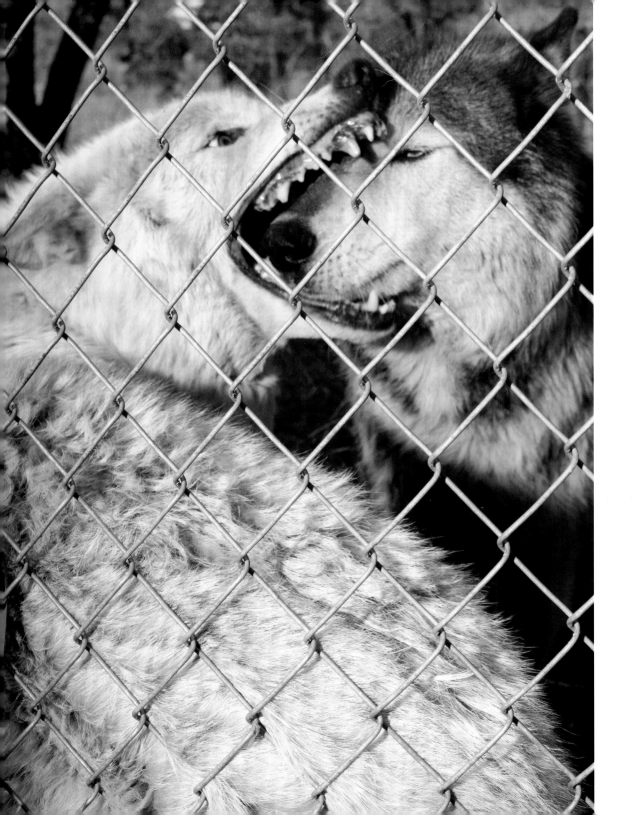

LEFT: *Jesse James (left) and partner Shiloh playing.*

RIGHT: *Merlin was originally held captive in Illinois to be killed for his fur.*

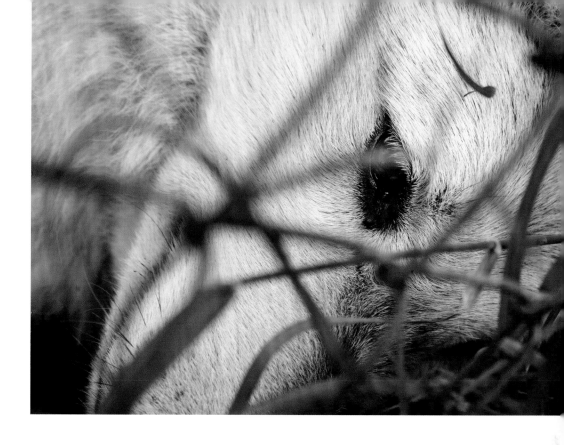

Ironically all of this regression to wolf control in the Rocky Mountain states since 2012 has simply backfired. New research from Washington State University analyzing twenty-five years of data from Idaho, Wyoming, and Montana reveals that the traditional wolf control tactics don't work—killing wolves actually *increases* predation of livestock. More dead wolves meant more dead sheep and cows. "It's counter-intuitive," says Rob Wielgus, director of WSU's Large Carnivore Conservation Lab. "People think, let's kill the wolves and get rid of the problem. But it doesn't work that way with carnivores. Sometimes, the punitive solution is causing the problem."

Why does killing wolves cause *more* livestock deaths? Weilgus discovered that killing wolves profoundly disrupts their social structure. "If you

kill the alpha male and female, the pack fractures," he explains. "Instead of one breeding pair, you may have two or three." And when large, older male wolves in a family are killed, younger males are more likely to go after livestock. In addition if one of the breeding pair is killed—as happened recently when the breeding female of Washington's Huckleberry family was shot by a state-hired marksman—then the wolf family destabilizes. A *New York Times* article on the study explains that killing wolves may in fact "make things worse as packs adapt, move around, and increase their reproduction rates—and then kill even more livestock the year after their numbers have been reduced."

What does this research mean about new ways of living with wolves? There is real hope that the West can find a different way of wolf recovery—and this new strategy means calling all the previously polarized factions to work together. The WDFW has hired veteran conflict-transformation consultant Francine Madden to "bring peace between parties at odds over how the state should manage wolves," writes the West's agricultural website Capital Press.

In the summer of 2015 Madden helped facilitate a tentative pact on wolf management that is both precedent setting and collaborative. Sheep rancher Dave Dashiell, who has reported more losses of livestock to wolves than any other rancher in the state, will be receiving financial support from conservation groups to help move his flock to northeast Washington. This partnership between ranchers and conservationists is "a great step forward," says Paula Swedeen, a biologist with Conservation Northwest. "It's a signal of getting over the divisiveness."

Washington wolf policy coordinator, Donny Martorello, says he couldn't have imagined ranchers and environmentalists working together like this even a year ago. The new pact is "amazing," he says.

RIGHT: *Lonnie creeping toward the fence.*

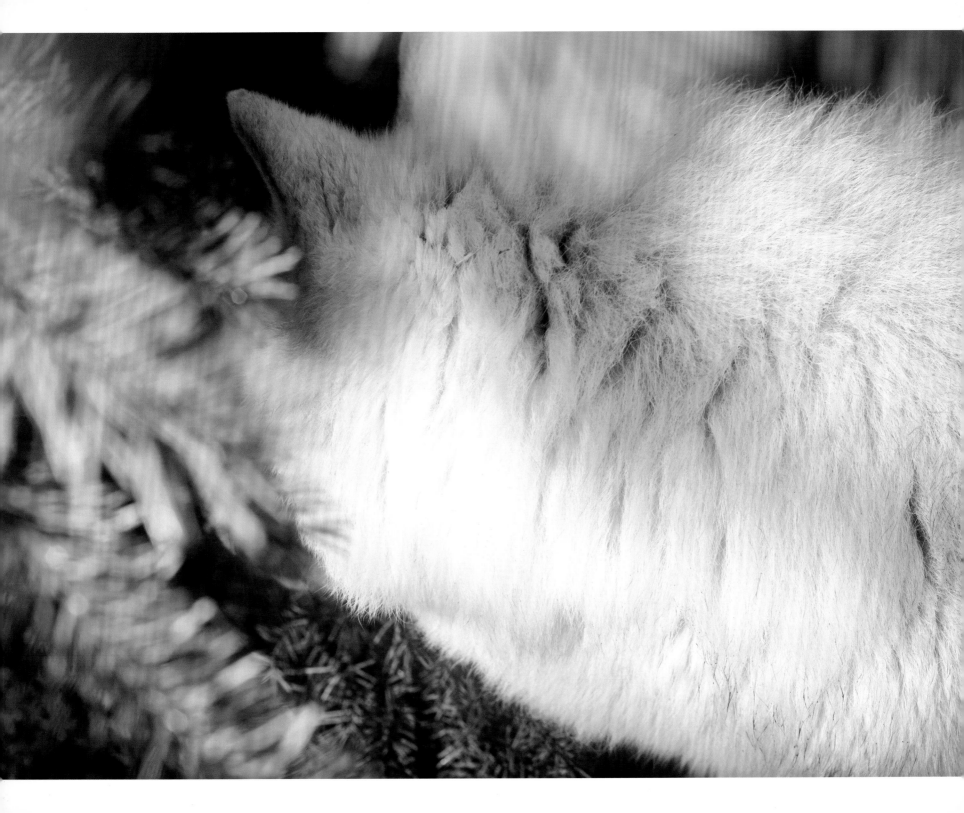

As the sun eases into late afternoon, we venture deeper into the Wolf Haven sanctuary where wolf pairs warily peer out from behind shrubs and trees. Diane explains, "The West has an historic chance now to be a model for wolf management. Wolf Haven is very active in also helping wolf recovery in the wild."

Diane credits the more open attitude of the West to the greater tolerance for wolf recovery that is grounded here in more ecological values. And she says, "All of us are going to have to collaborate and change and give a little. All of us deserve respect."

Wolf Haven is a member of the Wolf Advisory Group (WAG), which advises the Washington Department of Fish and Wildlife on wolf management strategies to reduce conflict with wolves. The WAG includes ranchers, hunters, and wolf activists.

The WAG listens to sportsmen, ranchers, and wolf advocates as they focus on science, education, and enlightened solutions. "The issues around wolf recovery are not black and white," Diane continues. "I also feel for the ranchers or livestock producers. Like the shepherd, whose ewes he's been working with for years to make high-end fleeces to sell to hand spinners. We really want to consider *all* stakeholders when we talk about restoring wolves here. We've got to listen."

Listening and nonlethal ways to handle wolf recovery are how these far western states differ from others where the first response is to destroy wolves in any livestock dispute. More ranchers in Washington State are now learning nonlethal and practical tools to protect their livestock against wolf predation: employing range riders or off-vehicle herders, *not* grazing sheep near known wolf ranges, removing animal carcasses that might attract predators.

Other practical tools include using bright red flagging, hazing sirens and automated lights, livestock guardian dogs, and more-carefully

LEFT: *Wolves have two layers of fur to retain body heat.*

patrolling livestock. A July 2015 front-page *Seattle Times* article "As wolves rebound, range riders keep watch over livestock," highlights a partnership between Conservation Northwest, WDFW, and forty-one ranchers that employs veteran "cowhands to watch over their herds and keep tabs on wolves in the hope of reducing conflicts with the new predators in the neighborhood."

"We wanted to find that middle ground and work with ranchers to give them the best possible tools for nonlethal deterrence," explains Jay Kehne of Conservation Northwest. The group raises money from donors to help ranchers implement these nonlethal practices. If ranchers sign a cooperative agreement with the WDFW to practice "conflict avoidance," they can receive radio collar alerts when wolves are near their livestock."

Every morning before saddling their horses, hired range riders can log into their computers and pinpoint where the radio-collared wolf groups are roaming. The *Seattle Times* article interviewed range rider Bill Johnson who pointed out that human presence is the best wolf deterrent of all. "Ranger riders are an old concept," says Johnson, "but they're relatively new again for the new generation of producers."

Washington wildlife officials took a much more balanced approach to wolf management in July 2015 when the Dirty Shirt wolf family killed three adult cows and a calf grazing on US Forest Service land in Stevens County. Even though the local cattleman's association called for immediate killing of the wolves, the rancher instead employed range riders and hazing with spotlights to guard against more wolf predation. This Dirty Shirt wolf family has one of the state's very few known breeding pairs. Jamie Rappaport Clark of Defenders of Wildlife praised WDFW for "doing wolf depredation management right" by employing nonlethal tactics with the Dirty Shirt wolves and for their collaborative efforts to

RIGHT: *Raven feather.*

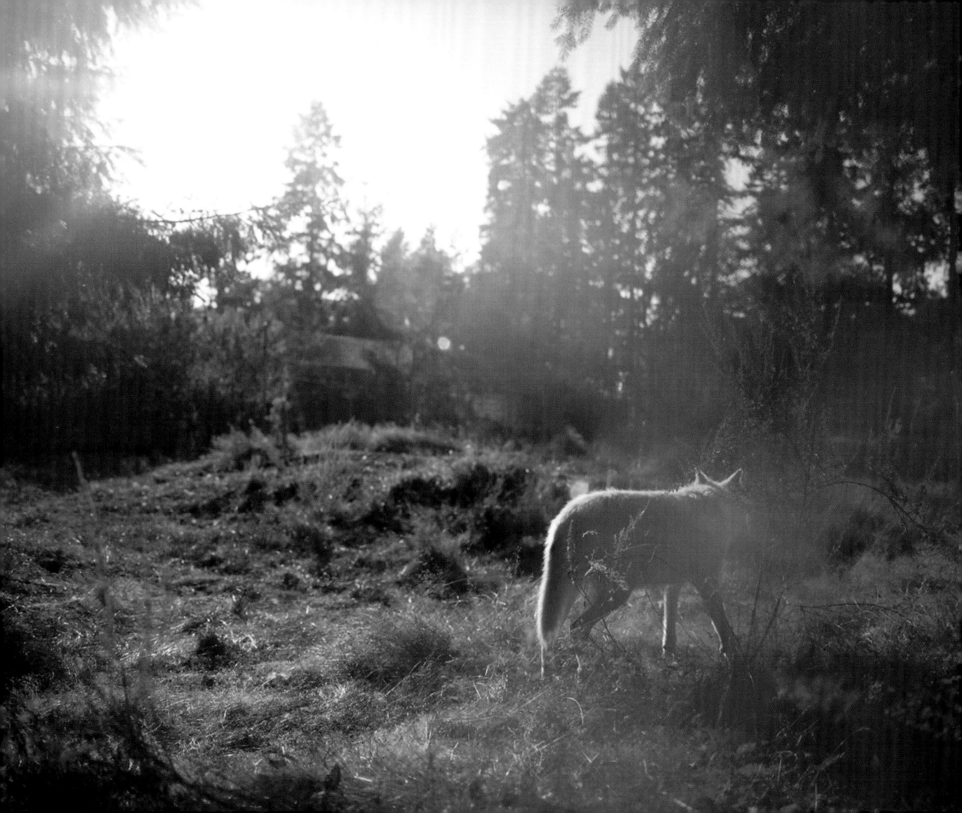

work with both livestock producers and conservationists to "allow wolves and livestock to safely share the same landscape."

Such visionary alliances between ranchers, wildlife managers, and conservationists are the hope of the future. Maybe as wild wolves return in Washington, Oregon, and California, there will finally be a truce based on trust between the warring human factions.

Rancher Sam Kayser, who pastures his cows on public land near Teanaway, Washington, echoes this. "I want to coexist with wolves," Kayser, who has raised two strong daughters who continue his ranching traditions, says thoughtfully. "I want to believe there's room for all of us."

———————————————————

The sun is slanting and cooler, prompting several of the wolf pairs to emerge from their trees and play. Now we silently stand watching the white wolf, London, as he slowly strolls near us. We stand very still as London sniffs the air. He is studying us by our scents: lemon face creams, tuberose and gardenia perfumes, mint toothpaste, and perhaps even our green mango iced tea drinks. Does London also smell the chocolate-walnut cookies we've snacked on?

Of course, we are strangers and London fixes us with his keen golden eyes, as his hackles raise up slightly. He is joined, and perhaps eased, by his delicate mate, Lexi, whose lustrous fur is tawny as a lion. Lexi rests her head on London's back and his hackles ease. His pale ears relax. Both London and Lexi have histories that no wolf should ever endure.

With legendary white-wolf grandeur, London was supposed to be a movie star. "But London flunked out of acting school," Wendy Spencer tells us, with a wry smile.

LEFT: *Wolf Haven at dusk.*

As London and Lexi nuzzle and trot away together, we're reminded that wolves have their own complex lives to lead. Lexi was rescued from an Alaskan tourist attraction called Wolf Country where she was chained to an eight-foot drag chain and visitors paid five dollars to see her.

All the wolves finding refuge here at Wolf Haven are carefully matched for temperament and partnership skills. "We don't force a relationship," Wendy explains. "We just let them come here and be a wolf so they regain a sense of self." She pauses as London returns nearer to her, exchanging a long tranquil gaze. "Here," she says softly, nodding at London, "they just get to *be*."

Just getting to be. Isn't that what every animal or human really desires—and deserves? In the West, the new stories we're telling are giving wolves a better chance not only of just surviving but *being*. Being back where they belong.

In the West there is real hope that we can find a more sustainable and balanced way to live with wolves, based on science not politics. We can see the wild wolf as a top predator and partner, instead of a threat. We can change our stories. The key is dialogue, education, and social tolerance.

California is also trying to model a different way to live with wolves. In the summer of 2015 a family of wild wolves returned to the state's Siskyou National Forest for the first time since 1924. Remote cameras caught images of wolf parents and their five pups frolicking in a high mountain meadow in Northern California. Named the Shasta pack, these first wolves in California were welcomed. In California wolves have been listed as "endangered" since 1973 and it is illegal to trap or kill them. The return of the wild wolf in this most populous western state was international news, covered by the media in the United Kingdom, France, and other countries.

RIGHT: *Samantha (foreground) and Bart at rest.*

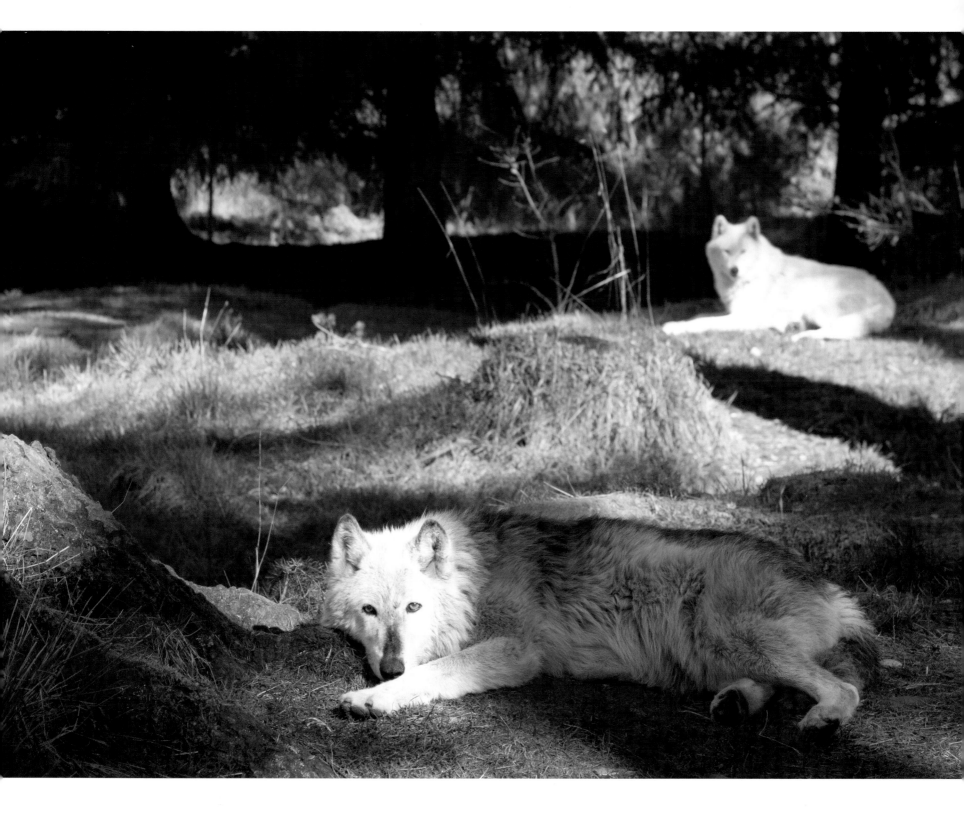

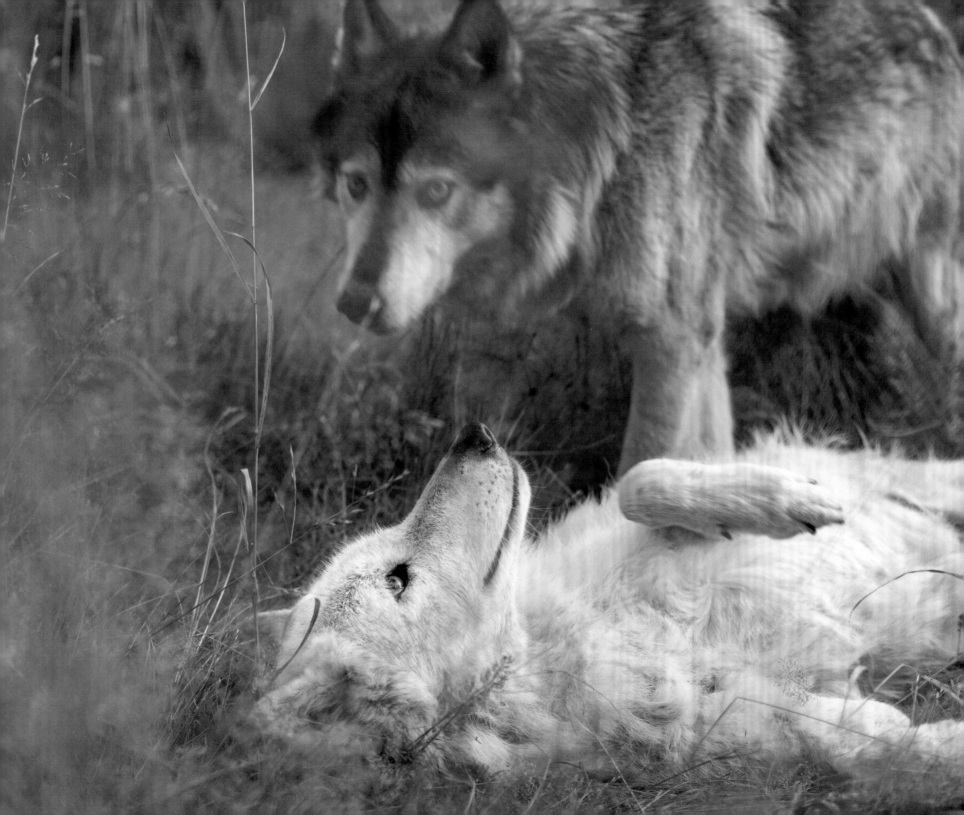

"This news is exciting for California," Charlton Bonham of the California Department of Fish and Wildlife said. "We knew wolves would eventually return home to the state and it appears now is the time."

This excitement echoes that of many other Westerners when a lone wolf, OR7, made the thousand-mile trek in 2011 from Oregon to become the first wolf to be sighted in California in almost a century. A new book, *Journey: Based on the True Story of OR7, the Most Famous Wolf in the West*, chronicles this lone wolf's epic and solitary sojourn from Eastern Oregon to Northern California in search of a new home and a mate. When his GPS radio collar batteries died, researchers figured OR7 was "doomed to a life of solitude."

"It was a real long shot that a female wolf would find him," said John Stephenson of the USFWS.

But then remote cameras unexpectedly revealed OR7 traveling with a slender darker female—and it was breeding season. It was a mystery where OR7's mate came from, but conservationists greeted her presence with excitement for the recovery of wild wolves in the West. By the summer of 2015 OR7 had fathered two litters of pups to form the Rogue River wolves, now ranging in Oregon.

Can the West truly model a new way of living with wolves, after the polarizing wolf wars in the Rocky Mountains and the controversial federal delisting of wolves in the Rockies and the Great Lakes region that many scientists believe was premature? Wolf biologist Dan MacNulty of Utah State University told *National Geographic* that the West *will* find a different strategy. "We are talking about wolves in the backyard of Portland, Seattle, Sacramento, and San Francisco," he says. "The social conditions are more accepting of wolves and there is great habitat."

LEFT: *Shiloh and Jesse James (on her back).*

This more open mind in the West does not mean that it will be easy to recover wolves. In late 2015 Oregon's wildlife commission voted to delist wolves, prompting lawsuits. In southeast Washington a farmer chased down a wolf in his car, repeatedly shooting at the exhausted animal; this was the first wolf in almost a century to be spotted in Whitman County. Conservation Northwest argued that Washington should maintain federal endangered species status for gray wolves and pass state legislation that requires twelve thousand dollar fines, similar to the one for grizzly and caribou poaching. Instead of punishing this inhumane and illegal killing of an endangered gray wolf with jail time and a five-thousand-dollar fine, as the law dictates, the state prosecutors simply slapped the farmer with a

LEFT: *Wolf fur on a branch.*

RIGHT: *Samantha.*

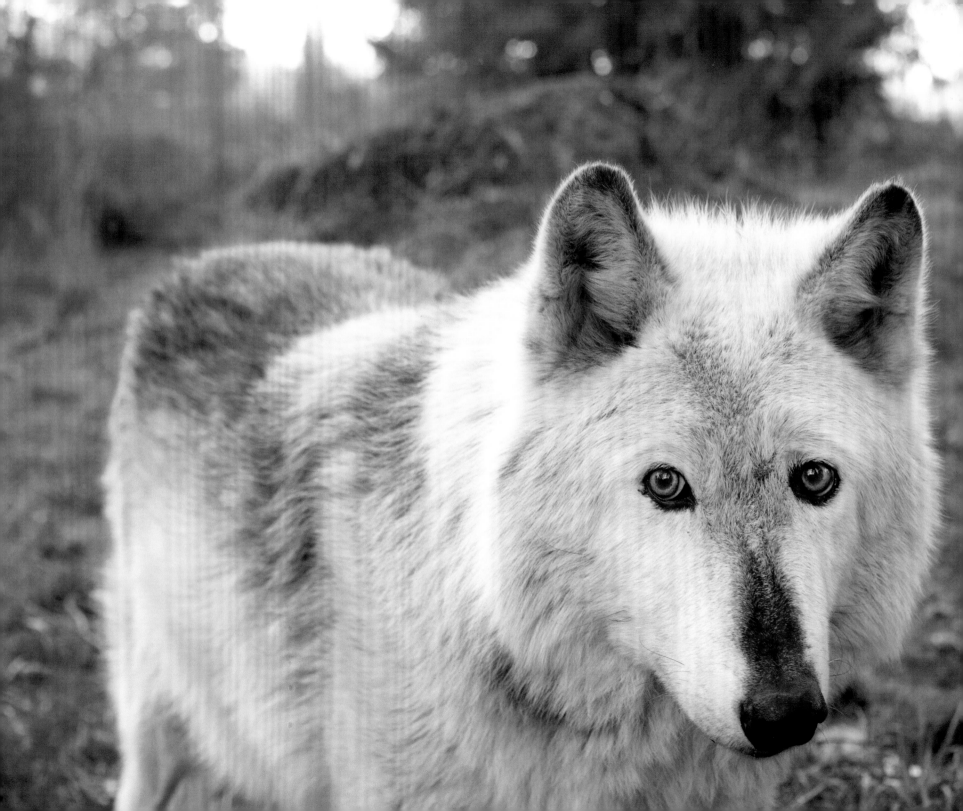

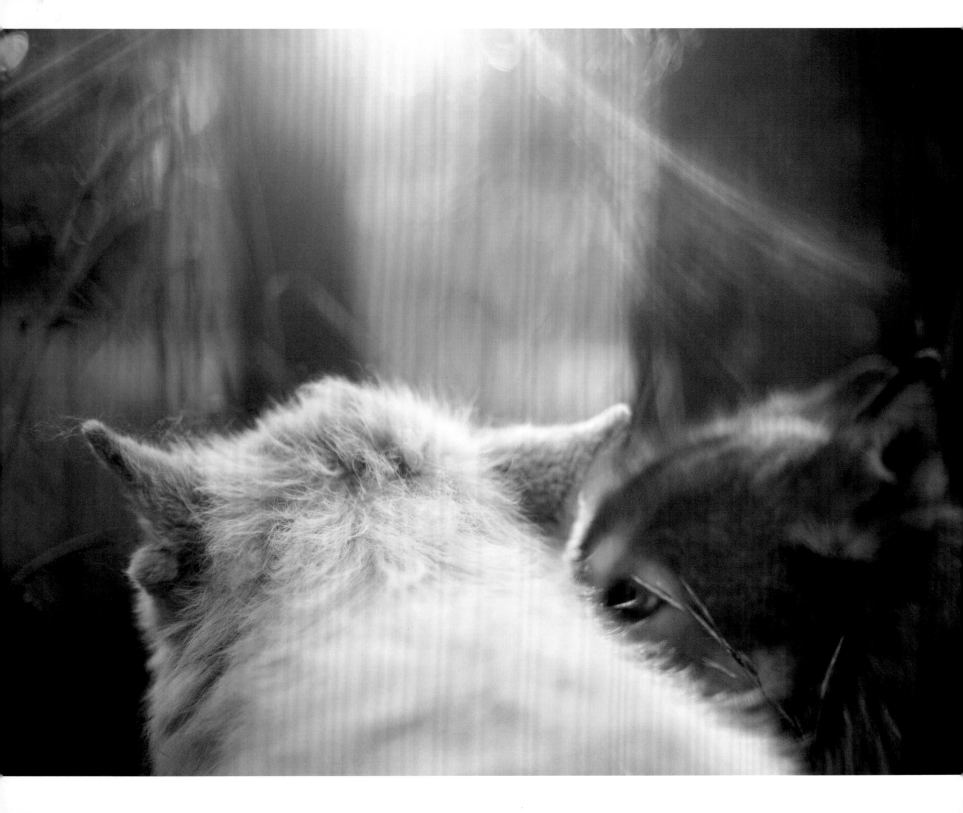

hundred-dollar fine and probation. People from as far away as Australia protested this farmer's car-chase rampage and wolf kill.

WDFW investigators said there were no reports of this wolf threatening people or livestock. The farmer justified his actions by saying that he "thought if the wolf was allowed to live it would kill animals in the future."

The future of wolves no longer just belongs to the hunters, ranchers, and farmers whose history and high stakes make them a vocal minority. Wolves, especially on our public lands, belong to us all. Many of us in the West rejoice at the return of the wild wolf to this vital homeland we all share. Here, wilderness is often just thirty minutes from our cities, and our pioneer roots are still close enough to us to remind us that what is tame is too often diminished and that what is domesticated can leave us lonely for the wild that we've lost. From Washington's North Cascades to California's Sierra Nevadas and Mojave Desert to the high plateaus of Nevada and Utah—the West has enough space to support two thousand wolves, say the wolf biologists. Here, a wolf should not have to travel a thousand miles to find a new home and his mate—to raise a family. There really *is* room for us all.

At Wolf Haven we gaze again at London. The evening shadows grace his white cape in fluttering silhouettes. It's time to let the wolves rest. As we quietly leave London and Lexi, they nuzzle one another and Lexi rests her head on London's sturdy back.

There has been so much war with wolves, I think. *Let there be some peace.*

Echoing my thoughts, Diane says softly, "If we can just focus on what we have in common—our next generations, better life for our children, and their healthy world—wolves and people will thrive." Diane concludes, "Everybody wants wild spaces. And what makes up wild spaces are wild animals."

LEFT: *Jesse James and Shiloh.*

RIGHT: *Riley.*

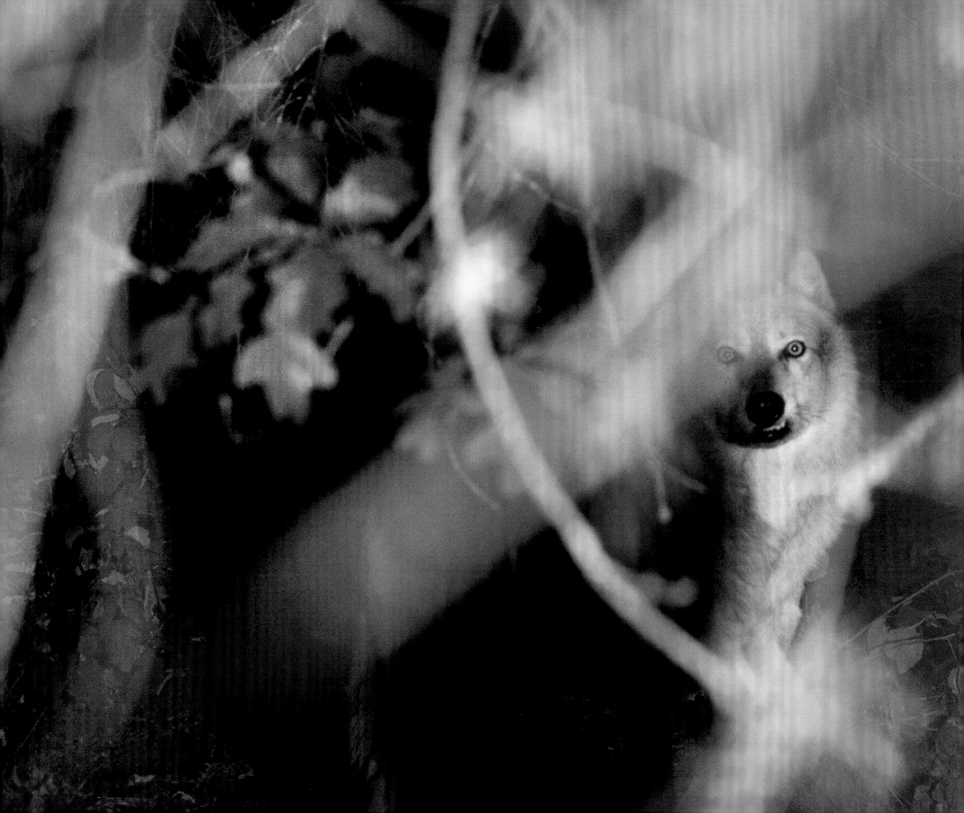

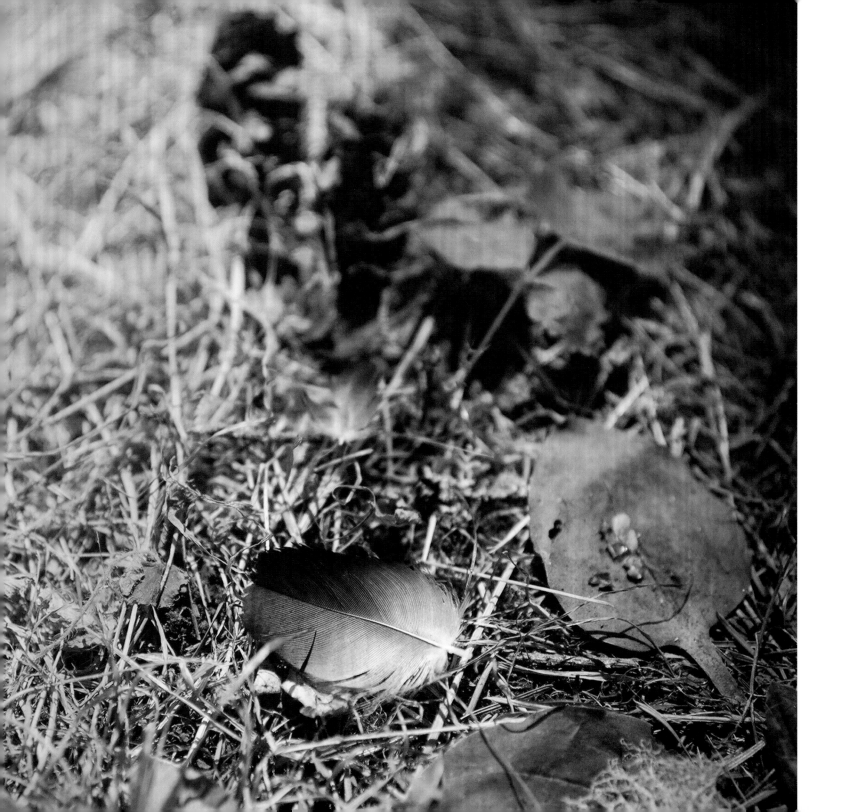

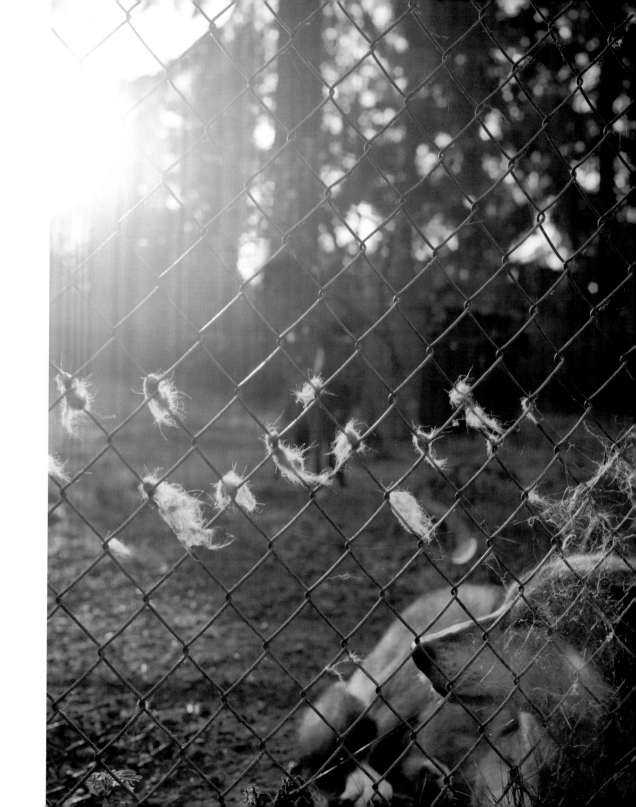

RIGHT: *Fur on the fence.*

RIGHT: *Caedus and Ladyhawk
are inseparable.*

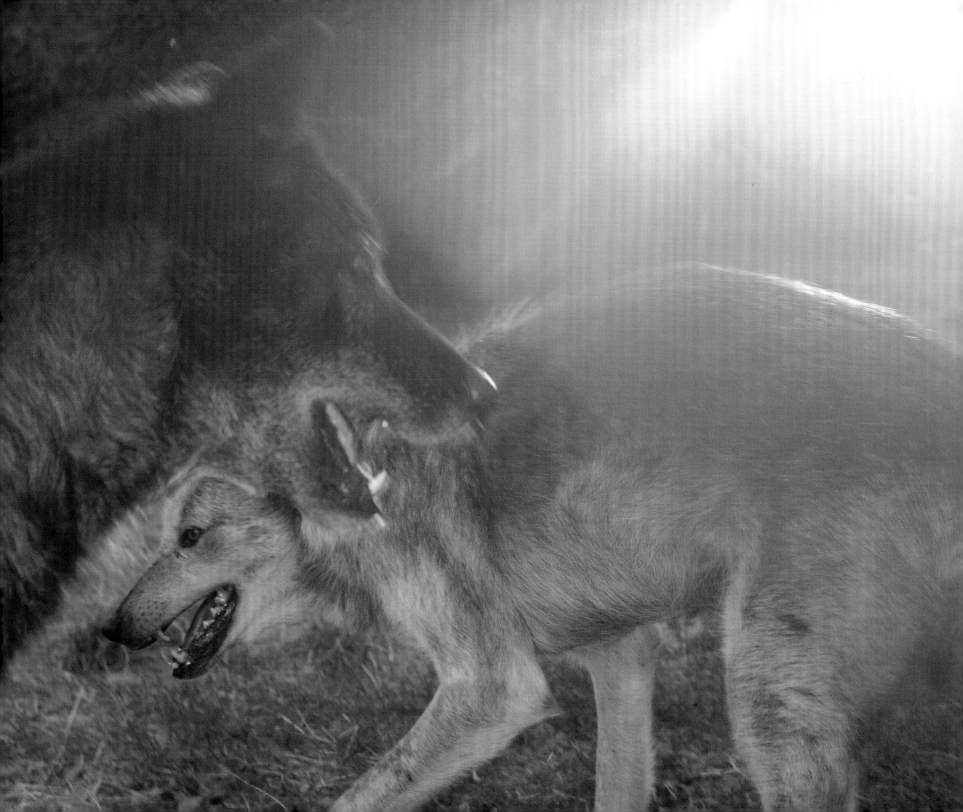

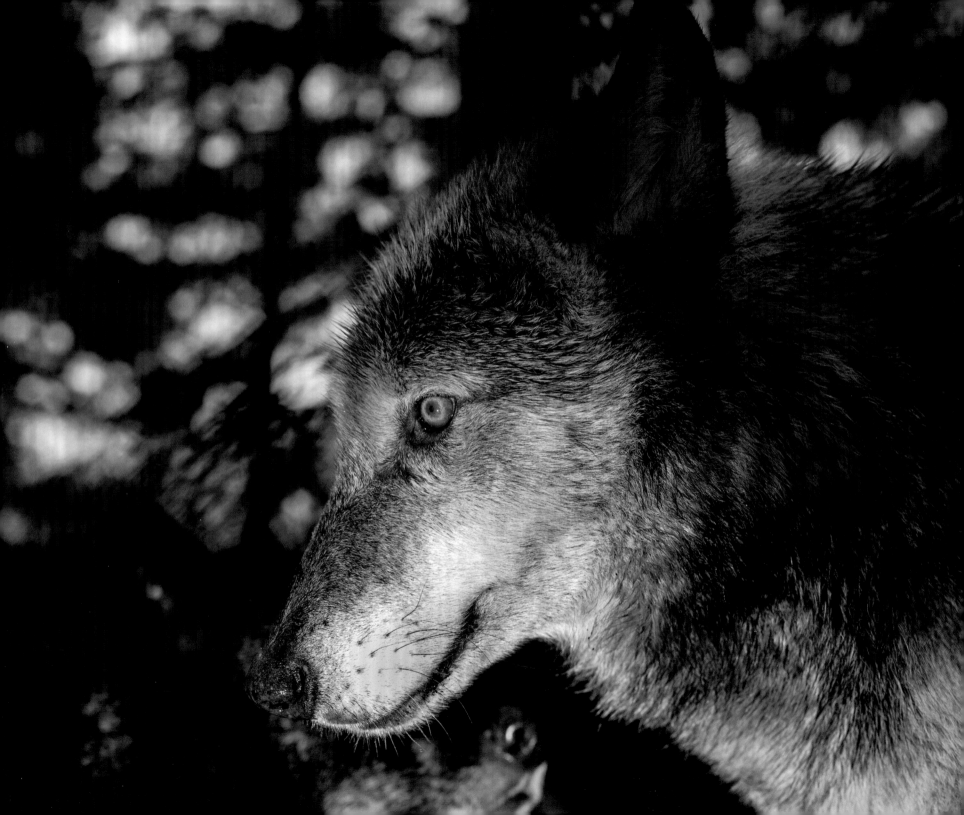

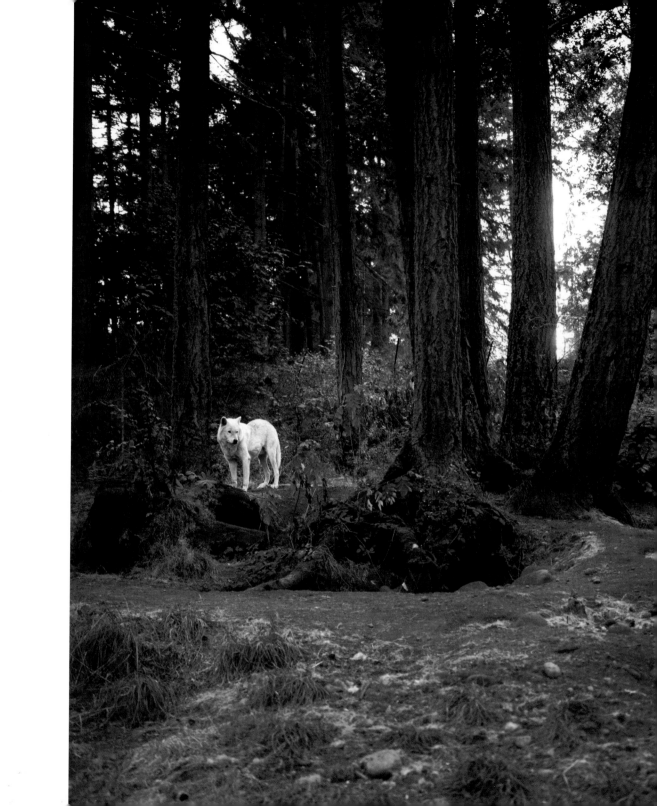

LEFT: *Ladyhawk protecting Caedus.*

RIGHT: *Nanook standing behind his den.*

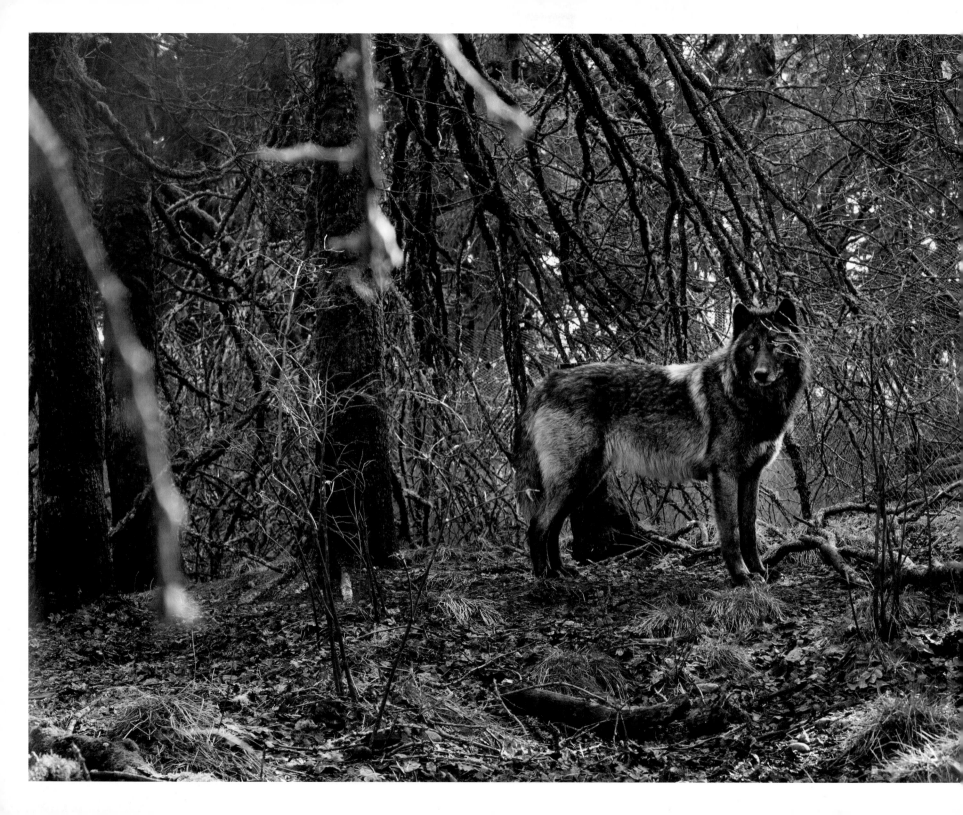

EVERY WOLF HAS A STORY

Strolling through a Los Angeles cemetery, someone is startled by a flash of silver fur. Maybe it's a trick of sunlight, the marble tombstones standing up silently like rows of illuminated books. But then, there it is again, a pale and fast streak between headstones. Is it an unleashed dog racing through the dearly loved dead? Is it perhaps a fox roaming far away from some nearby blonde, grassy canyon? The stroller stands perfectly still, hardly breathing. At last an animal hesitantly emerges from behind a stone angel, first a long sinewy leg, a thick silver buff tail, and then the bright golden wolf eyes—not fierce but frightened.

Impossible, thinks the stroller. *Must've wandered onto a movie set.*

This is, after all, Hollywood. A place where all sorts of otherworldly creatures roam our imaginations, if not our woods. But it's not a film set. There are no directors or actors or crew. Just this single gray wolf, who seems completely lost.

"We don't know how Lonnie ended up in that graveyard," says Wendy Spencer as we contentedly watch Lonnie and his wolf dog companion, Meeka, play together. When Lonnie was found and taken to a rescue shelter in California, he was quite young. But the rescue center couldn't keep him, so in 2009 Lonnie was given refuge here at Wolf Haven. Meeka is also from California, in the Mojave desert. She is naturally robust and

less shy than Lonnie. She approaches the fence and ambles alongside it, unafraid of us. Perhaps it's the dog in her.

Wolves and wolf dogs don't seem to pace their territory at Wolf Haven. Not like at a zoo, where so many animals fidget and endlessly patrol their small perimeters as if desperately looking for a way out. Here in this sanctuary, the public enters only by appointment so as not to overwhelm the animals. All the wolves are partnered so appropriately that they seem at ease with one another and with the carefully selected visitor times. As Diane Gallegos points out, "This is a true sanctuary, devoted first and foremost to the wolves." Wolf Haven International was recently honored with accreditation from the Global Federation of Animal Sanctuaries, the only wolf sanctuary in the world to earn this distinction. The GFAS accreditation panel noted, "It is heartwarming to see animals that were once neglected, abandoned or abused receiving the high quality, lifelong care, and respect they deserve."

At Wolf Haven the majority of wolves are not for public viewing. Some of these wolves have been so badly traumatized by their time with humans—held captive on eight-foot metal drag chains, like Eve and her younger sister, Samantha, who both languished in an Alaskan roadside attraction for nine years. Others were abused by people, like Shadow, whose teenage buyers had no idea how to care for a strong wolf pup, or Lakota, a gray wolf bred for sale but who still had so much of the wild in him that his owner planned to euthanize him. These wolves simply need the rest of their lives to recover. In other words they need to just be among other wolves.

———————————

Every wolf, like every human, has a story. Some stories may have a tragic ending, especially for the red wolves in the wild, though not here at

PREVIOUS PAGE: *Shadow.*

RIGHT: *Jesse James and Shiloh in the summer.*

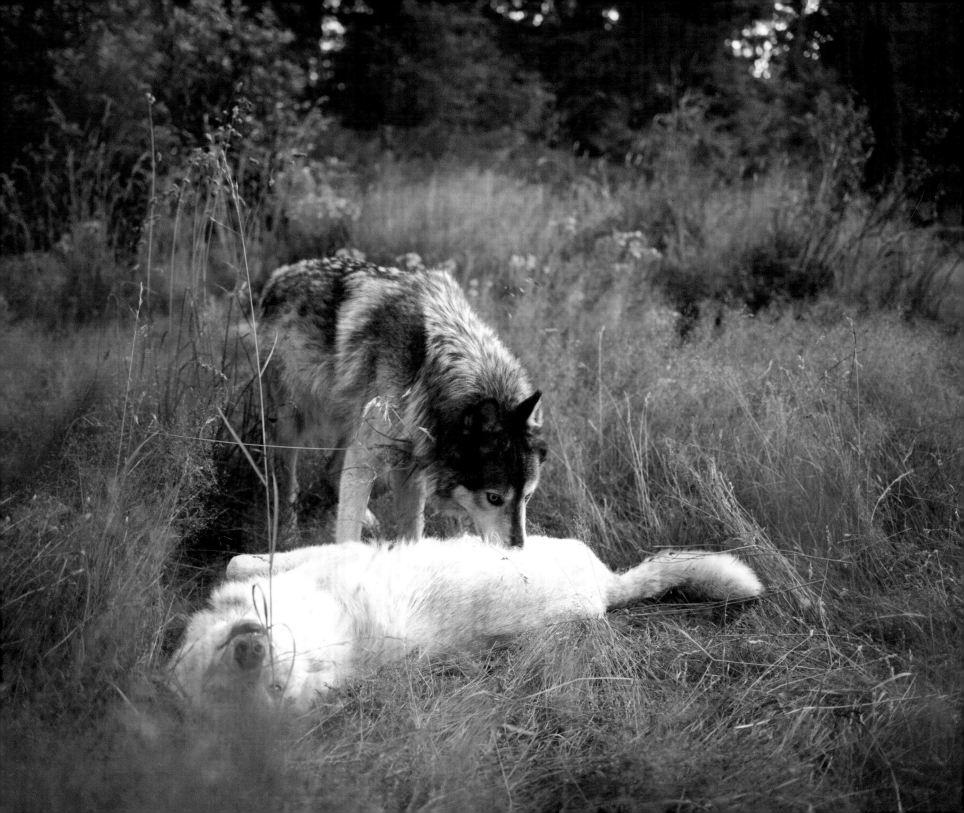

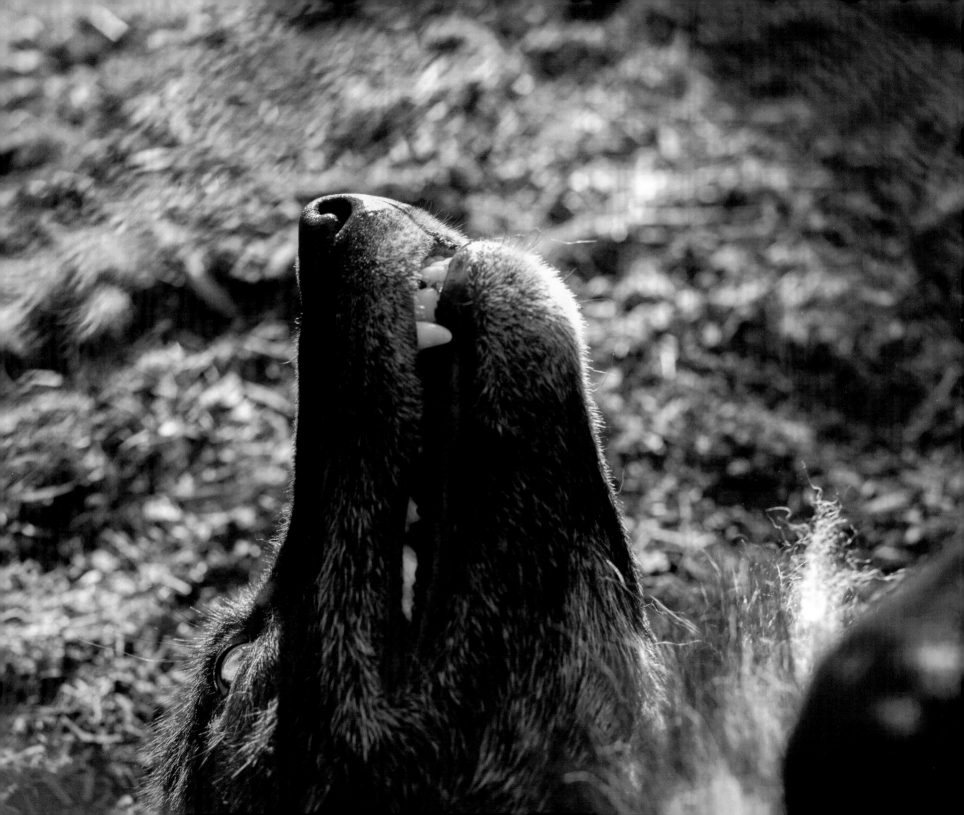

Wolf Haven. In North Carolina—known for its conservative politics not conservation—red wolves may well go extinct. This most highly endangered and dwindling red wolf population is barely hanging on in northeastern North Carolina. A very hostile state Wildlife Resources Commission has passed a resolution asking the USFWS to end the twenty-seven-year red wolf recovery program. With only fifty to seventy-five wolves surviving in the state, North Carolina has also decided *not* to release any more new red wolves into the wild. This means no more captive-bred red wolves will be reintroduced in 2015, after only two red wolves pups were

cross-fostered into wild dens in 2014, hardly enough to sustain a future population with genetic diversity.

As we stand watching Tala and Nash (the two red wolves live together at Wolf Haven), Diane comments on the difficult science of getting more genetic diversity into this red wolf population. "It's like computer dating for wolves," she explains. "All the complex science that goes into trying to keep a very small population, like red wolves, healthy."

Tala and Nash are both remarkable for their distinctive ginger-brown fur, their ears tinged with auburn highlights. Nash's head is delicate and feminine, while Tala's jaw is mighty and masculine. *Tala* means "wolf" in the Sioux language. Very light on their feet, these wolves seem tentative. Once red wolves roamed the entire southeastern United States, but by 1980 the endangered population was listed as extinct. It was only through a diligent reintroduction of red wolves in 1987 that the red wolves began to recover. But by 2013 there were fewer than one hundred left.

In the spring of 2015 a North Carolina landowner shot one of the last surviving red wolves, a nursing mother, when she wandered out of the safety of the Alligator River National Wildlife Refuge. "That mother's remaining puppies are in danger now," said Kim Wheeler of the Red Wolf Coalition. "And her future puppies will never be born."

That's where the captive-breeding program at Wolf Haven again can play a vital part. "Three pairs of red wolves have been recommended for breeding," says Diane as Tala trots out toward us cautiously and then, in a split second, dashes away.

We watch Nash, almost hidden behind a large tub of water, reminding us that wolves enjoy water and are excellent swimmers. "Nash is new to Wolf Haven," Diane says, nodding at this graceful female with pride. "We feel really fortunate to have these four red wolves protected in sanctuary here."

RIGHT: *Wolf Haven is part of a Species Survival Plan that breeds the Mexican gray wolf.*

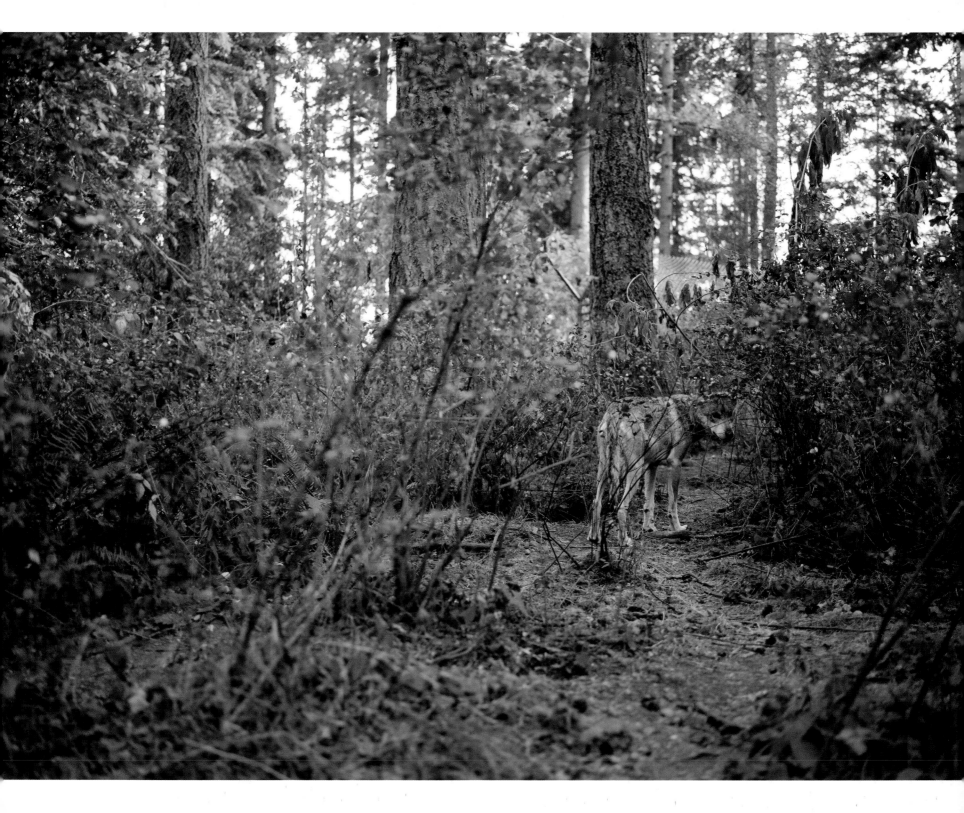

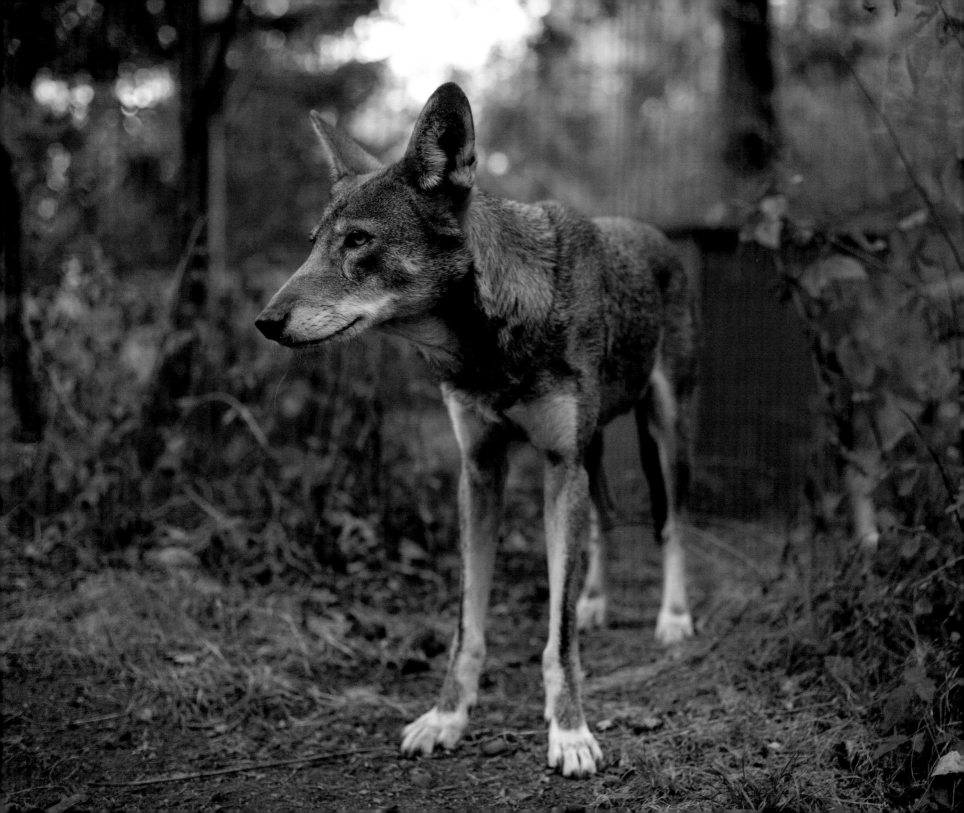

For now the Red Wolf Recovery Program in North Carolina will continue, but it, like the wolves themselves, is under siege. Many illegal killings of red wolves—twenty-three out of fifty-eight red wolves shot between 2012 and 2015—are a result of the USFWS having given private landowners authority to kill wolves. The USFWS is actually now considering simply letting this red wolf population, one of the world's most endangered wolves, go extinct again—even though local landowners have signed a petition supporting red wolf recovery.

A new lawsuit against the USFWS argues that North Carolina's wildlife managers have a responsibility to protect red wolves. "The service's decision to halt its successful reintroduction program reflects an abandonment of that duty," says Sierra Weaver, with the Southern Environmental Law Center.

Wendy recently attended the Red Wolf Species Survival Plan meeting in Missouri with scientists and federal wildlife managers. "We're hoping we're not going to be too late for these animals," she says somberly.

Tala finally trots out toward us and lowers his handsome head, looking up at us with those piercing amber eyes. There is a soft, haunting quality in his expression that it's difficult not to interpret as sorrow. Does an animal intuit when all of his kin are dying out? What does it feel like to be the last of your line?

Rich Anderson, who helped with the early red wolf recovery programs, commented on the uncertain future of red wolves. "We have a chance to conserve these really rare red wolves," he said. "If *you* could help save a whole species in your lifetime, wouldn't you try?"

Other wolves, like Ione, should probably be much more like Tala and Nash—aloof from humans. In 2011 a Stevens County rancher was shocked

LEFT: *Jacob, a red wolf.*

to catch sight of a wild wolf returning every night to seek companionship with his dogs. Though the beautiful dark-ember female wolf showed no interest in killing livestock and stayed well clear of people, a ranch is not a good habitat for a wild wolf. What had happened to this lonely wolf's family that it sought out the company of dogs?

Wendy explains that each wolf family is "rich with traditions like hunting strategies that are passed down from generation to generation. . . . Research has shown that wolves learn much of their survival skills from family members." Without parental guidance, when young animals disperse at about twenty-two months of age, they may not have learned all they need to survive well on their own.

Ione's original family was the Smackout family that had lost its breeding male when he was struck down by a vehicle. This loss of a parent severely disrupted the Smackouts, and they had to form smaller groups—Carpenter Ridge, Dirty Shirt, and Ruby Creek, which was made up of two sisters, including Ione. The two glossy black wolves were often seen hanging around with domestic dogs, and because of their visibility, they were named Thelma and Louise. Like their female namesakes in that film, Ione and her sister were certainly "on the run." Their lives were as compromised—and potentially as tragic.

Wandering in search of a mate is an archetypal story for both humans and wolves. When Ione's sister actually bred with a local rancher's guard dog, WDFW had to capture, spay, and release her, then a car killed her. So Ione was on her own, and there were not enough wild wolves around in the region to keep her company. Wolves being highly social animals, it made wolf sense to seek out some kind of canine family bond and territory. She'd lost her family and her sister. Her life depended upon finding home and community.

RIGHT: *Asleep in the woods.*

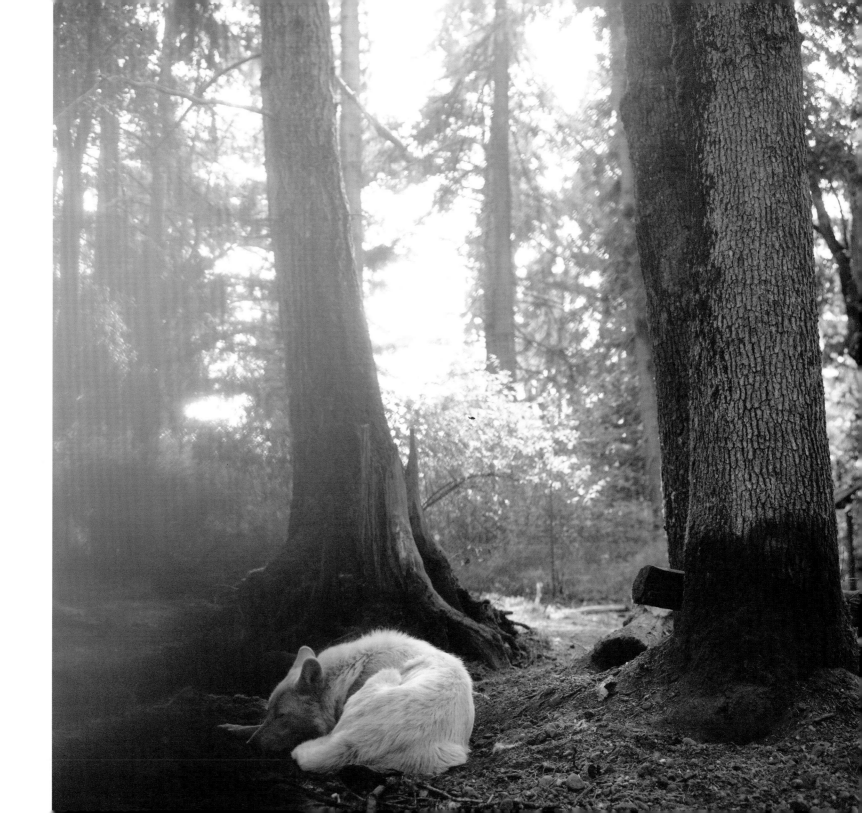

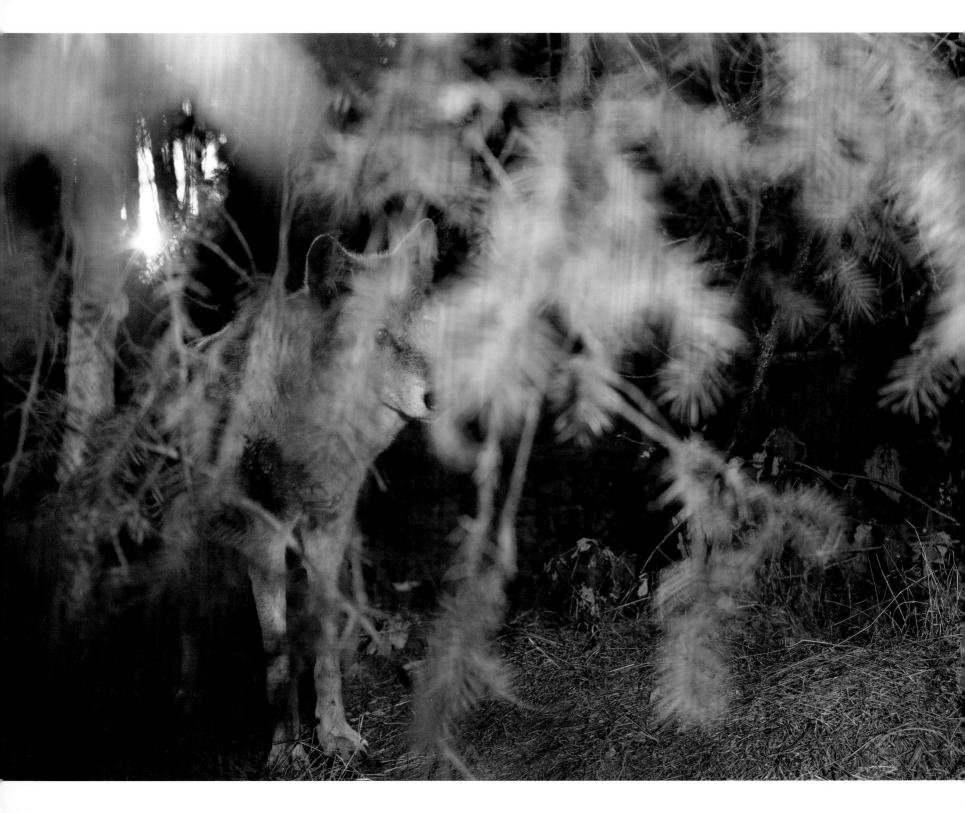

Often the rancher would begin his morning by finding Ione "curled up outside the dog's kennels." This rancher practiced sustainable farming and witnessing this lonely wolf—so unlike the stereotype of a livestock-ravaging beast—gave him a deep appreciation for her plight. Many others in the local community who'd seen Ione felt compassion and empathy for her struggle. Instead of acting out of fear or prejudice and simply shooting this lone wolf, everyone came together to respectfully dialogue about Ione's survival. WDFW, along with Wolf Advisory Group and local people, looked at two options: lethal removal or translocation.

Neither was a really good solution. "Ione had done nothing to warrant destruction," Wendy explained. And the local people had grown to respect and care about Ione's survival. As for locating her elsewhere, Ione had already shown that even though she traveled many miles a day, she would loyally return every night to the ranch and her dog companions. After much pondering, Wolf Haven offered a third solution: sanctuary.

In the thirty-three-year history of Wolf Haven, only one other wild wolf had ever been brought into the refuge. "We agonized over this decision," remembers Diane. "Some wild wolves adapt to captivity. Others do not."

But Ione was still so young and already habituated to human presence. If anyone was going to adjust, she might. Ione has only been at Wolf Haven since February 2015. She is not on public display, but she has found a fond companion in the male wolf dog, Luca, who is her age. Luca arrived with Merlin in early 2015. Both wolves were originally held captive in an unkempt facility that was raising them to be pelted out, in other words, killed and skinned for their fur.

"Don't you think they look much better in their *own* coats?" asks Diane when she introduced the new Wolf Haven trio to the annual meeting of

LEFT: *Siri.*

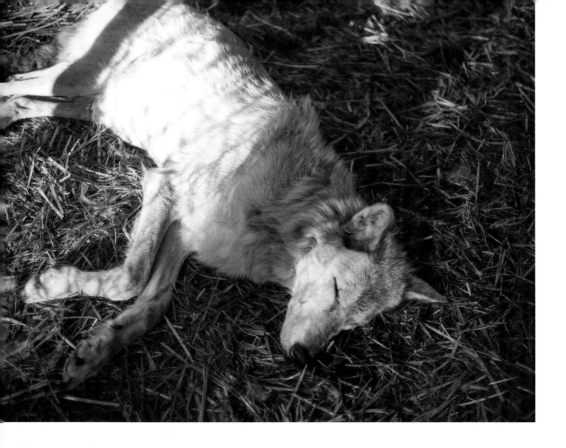

supporters and volunteers. Her words were met with fierce and resounding applause.

Though Luca and Ione are kept away from the public view in their large enclosure, Wendy tells us to stand very still on the path, a distance from them.

"There!" She points out a sudden movement in the distance way behind the public viewing enclosure.

Just for a second, Ione's shiny black body flits between tall trees. *That's the way it should be with wild wolves,* I think. Hidden, keeping their life-saving distance from us. Ione remembered those native survival skills here at Wolf Haven. Now that she has a close companion again, she no longer needs humans or our ranch dogs.

LEFT: *Kiawatha taking a nap in the midday sun.*

RIGHT: *Lonnie seeks the high ground.*

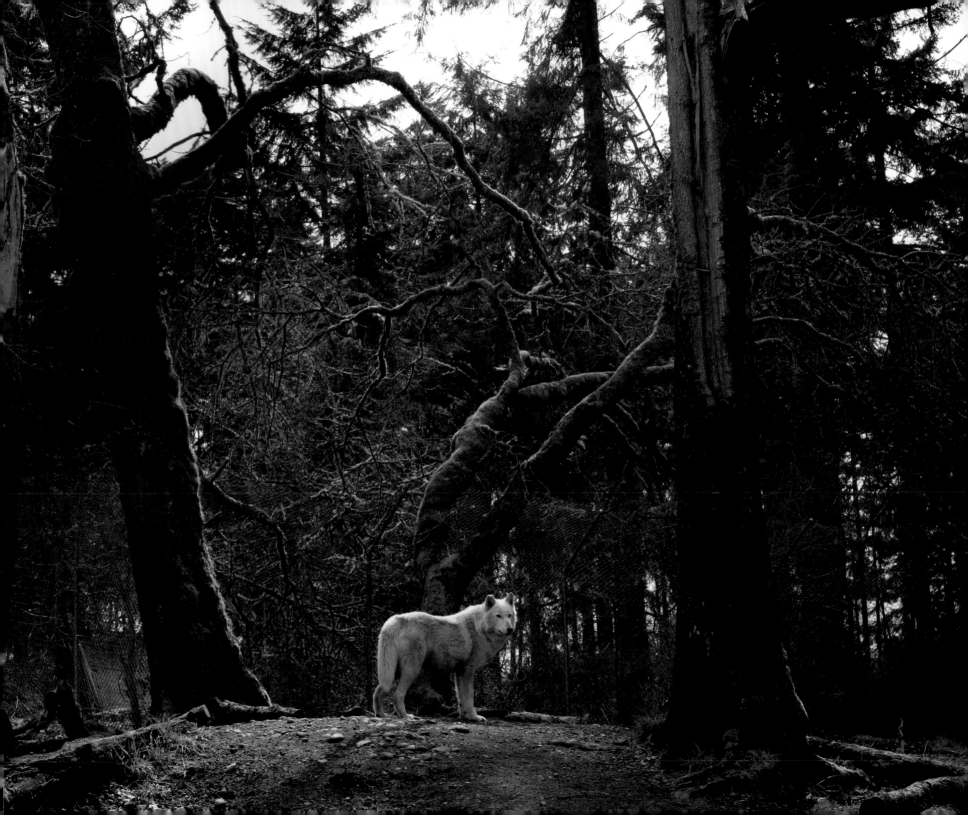

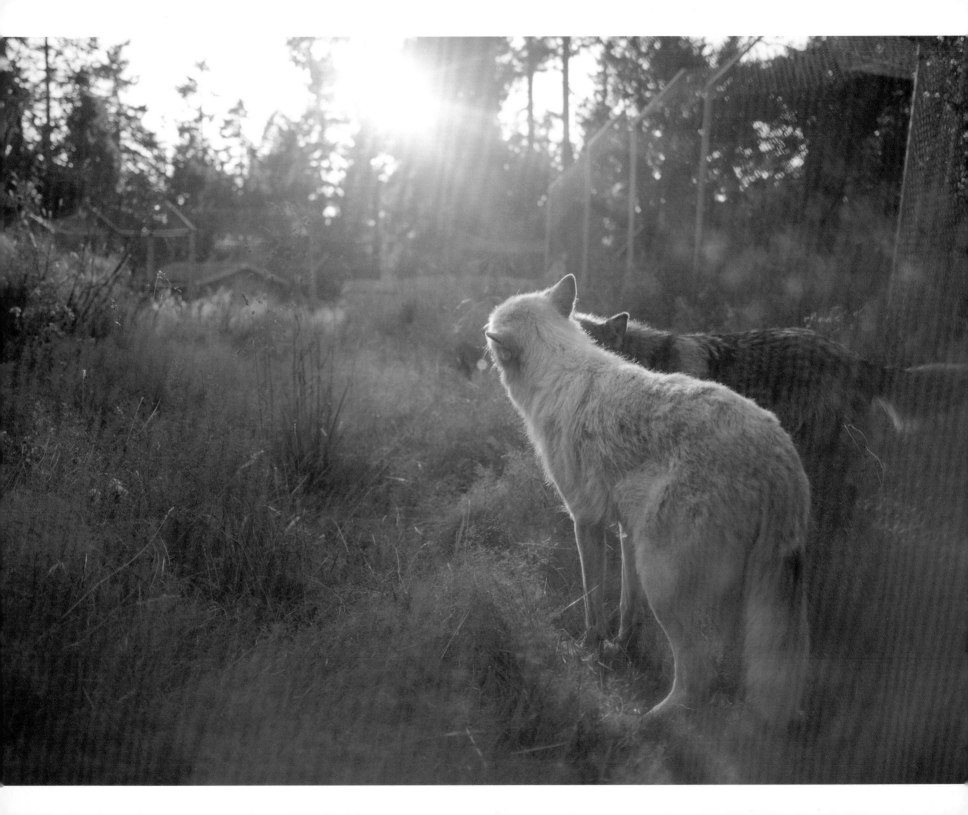

"Luca is not dominant nor high-strung," says Wendy. "Ione seems to cue off him, which has a calming effect. We often see them engage in play."

Ione will always have a wildness about her that is not seen in many of the other Wolf Haven animals. This wildness will always "serve as a bitter-sweet reminder of what she has lost."

So many of the wolves in this sanctuary have lost much—the wild, their freedom, and sometimes their families. But every wolf here has, in his or her own way, also been found. Yes, they have lost their freedom, but they are also given the extraordinary and skilled compassion of human care. Just like every wolf, every human volunteering at Wolf Haven has a story. Often it is how they first encountered wolves and so committed their lives to educating others about their value in balancing our ecosystems. To witness a wolf in sanctuary or free in the wild is both a privilege and a responsibility.

Do the wolves at Wolf Haven sense that they are held safely and skill-fully here by over thirty years of human love? Many of us who work for wolves believe that a lasting peace with wolves is possible and, in fact, is the real future for *Canis lupus*.

"What we can offer these wolves is lifelong sanctuary, respect, and our deepest devotion," says Diane.

As we all finally take our leave of the wolves for the night, several soft howls echo through the cool trees. The wolves return to their own good company.

LEFT: *Jesse James and Shiloh. It only takes two wolves to make a pack.*

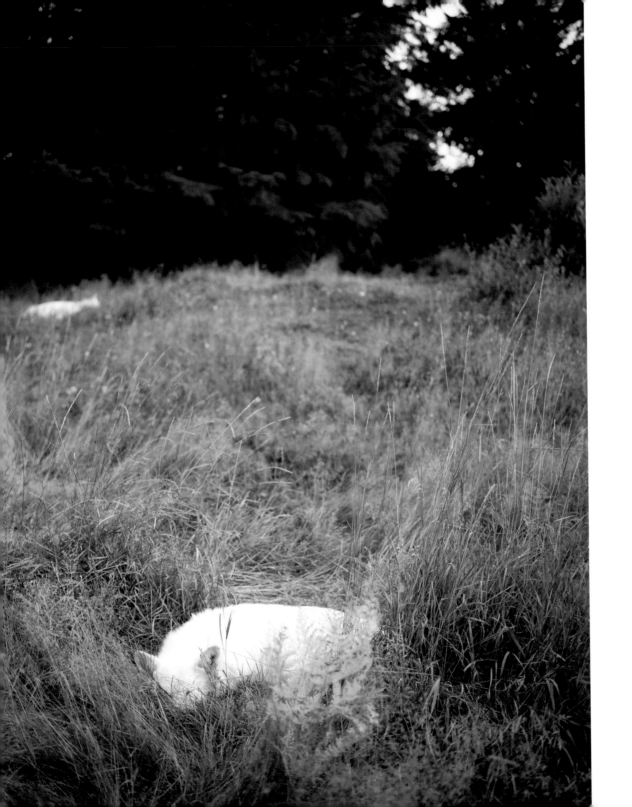

LEFT: *At Wolf Haven each wolf has a partner and a large enclosure.*

RIGHT: *An owl pellet in the sanctuary forest.*

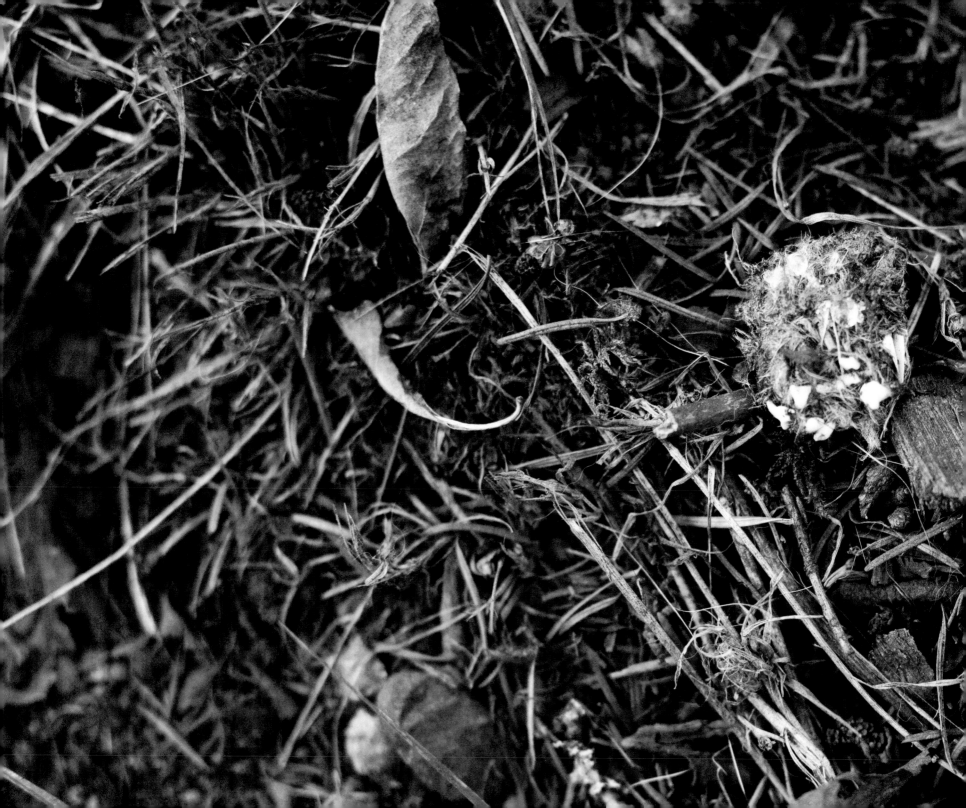

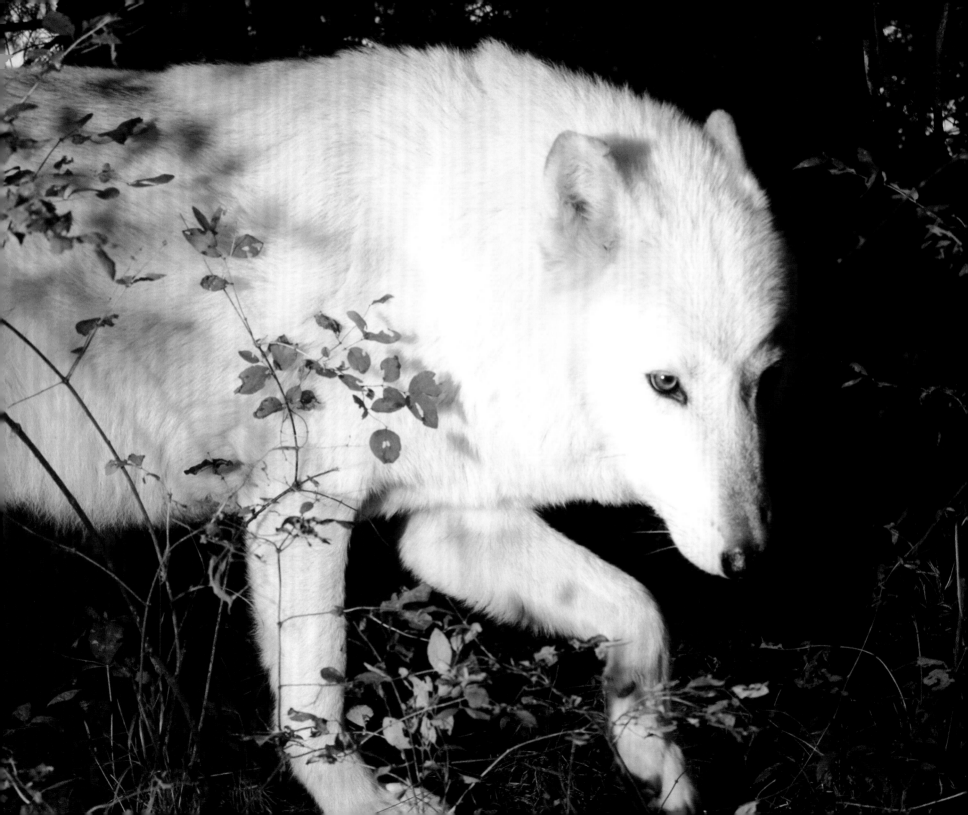

LEFT: *Lonnie.*

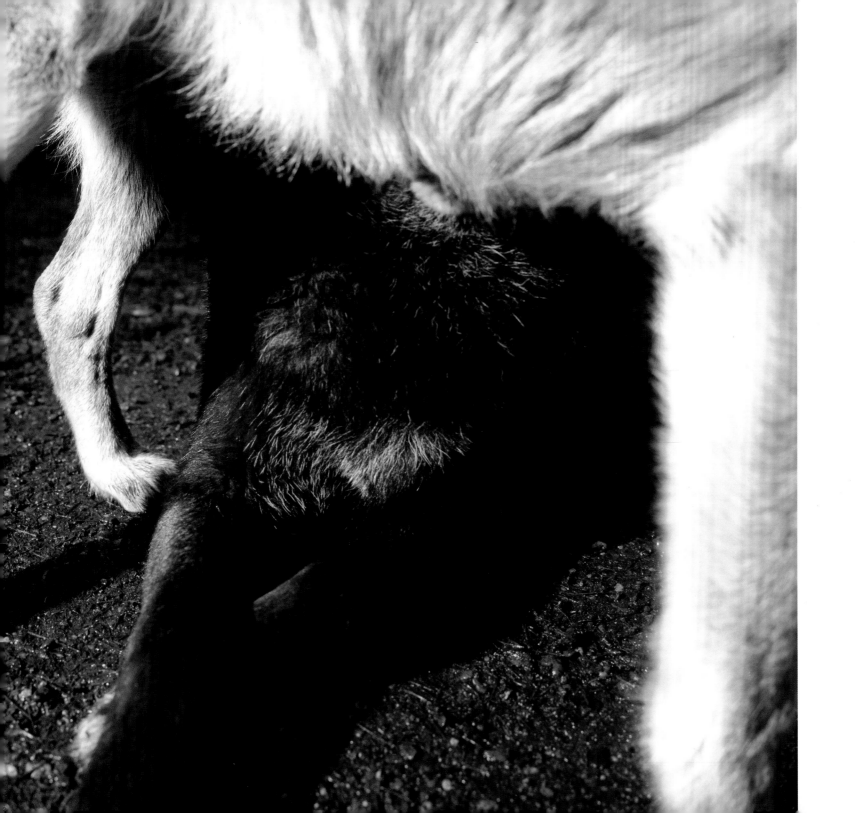

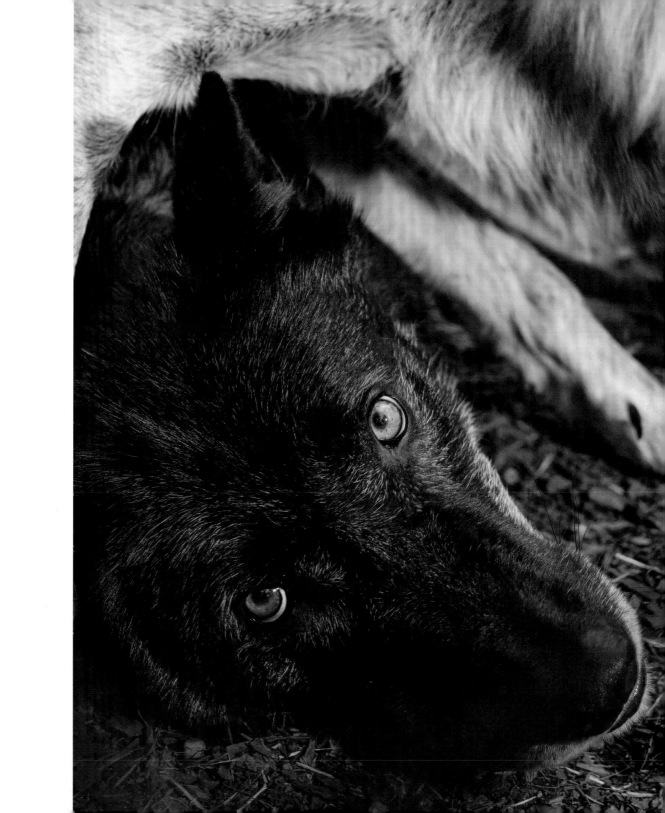

LEFT: *Ladyhawk standing over Caedus.*

RIGHT: *Caedus lying beneath Ladyhawk.*

RIGHT: *Annual wildlife-handling class.*

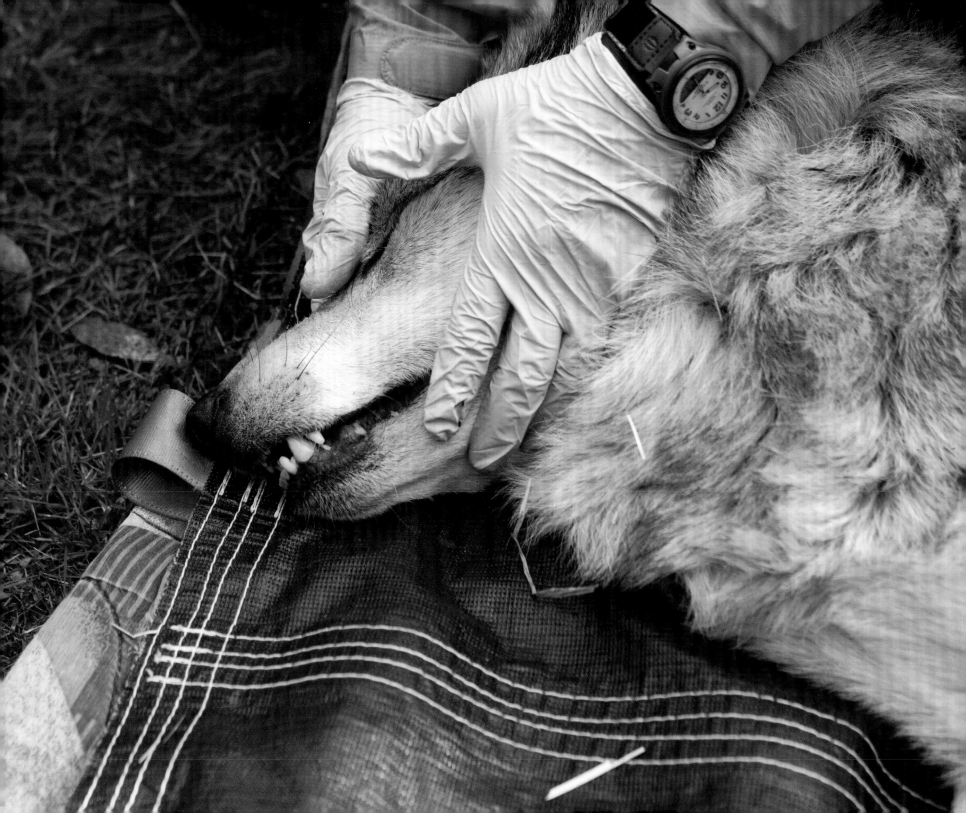

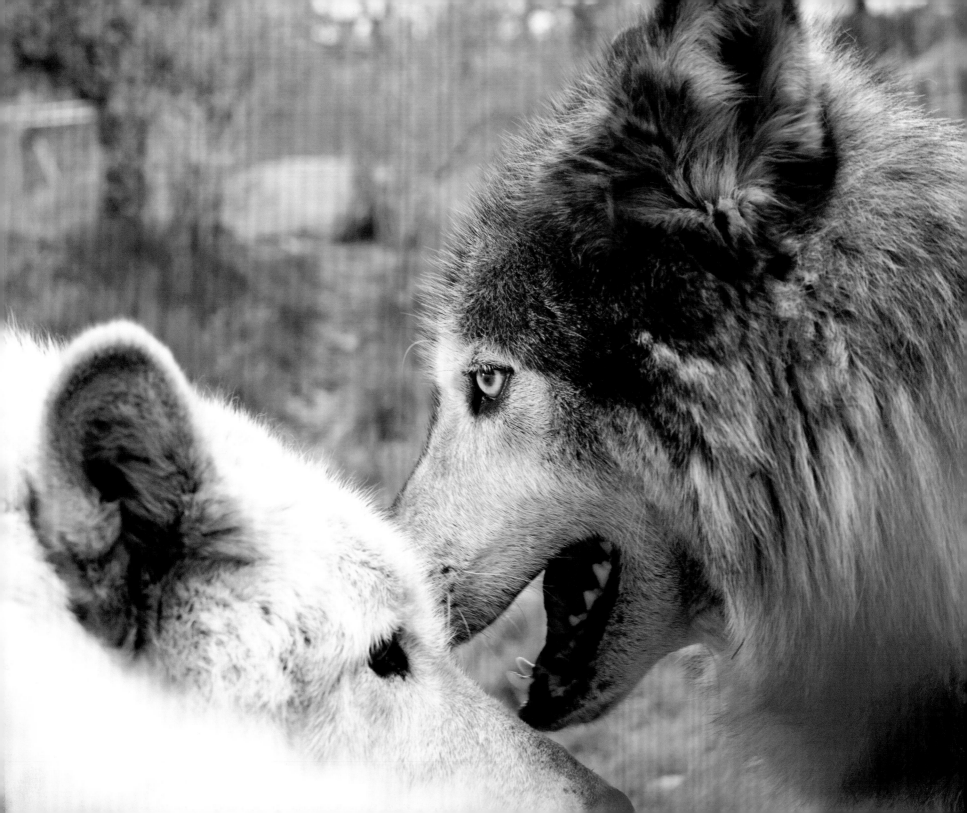

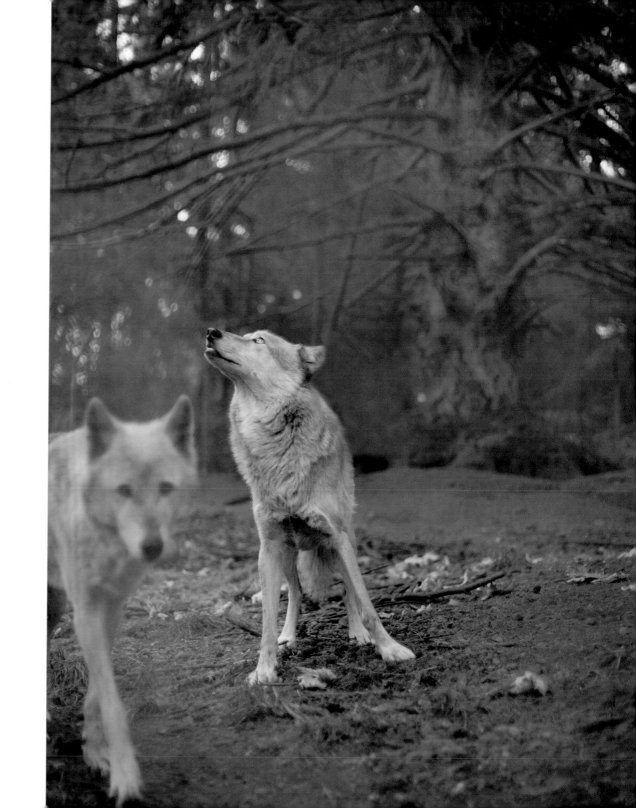

LEFT: *Shiloh (right) communicating with
Jesse James.*

RIGHT: *Siri (left) and Riley with
autumn leaves.*

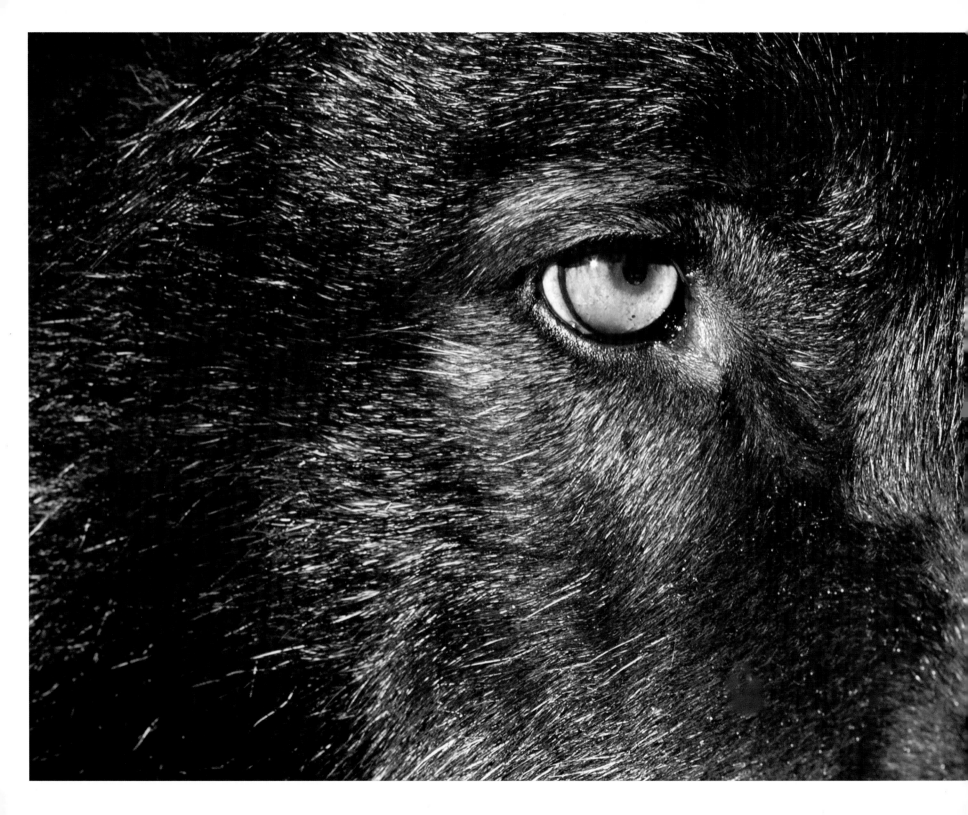

PHOTOGRAPHER'S STATEMENT

"How can I photograph anything from behind a fence?" I wondered, given the restriction at Wolf Haven that my subjects would be on one side of the barrier and me on the other. Still, I was anxious to start shooting, and despite a storm warning, I drove the seventy-five miles from Seattle to Tenino in tense slushy traffic. Then I arrived at a kind of forested wonderland complete with jet black ravens circling above. I pinched myself. Dream or reality? Mature trees blanketed by moss towered overhead; a vast prairie bordering the sanctuary was alive with pocket gophers, bald eagles, hawks, and an array of other lush flora and fauna. Everything seemed to glitter, although it was dark and cold at noon, no sun in sight. All I heard were ravens chortling and the wind whispering in the trees. Wendy stood next to me—a kindred spirit for sure—giving me the lay of the land and describing my boundaries, and how to act around these timid-fierce creatures.

Then I saw the wolves.

They appeared softly from behind trees and branches, looking intensely at me, taking me in, remembering me.

The previous spring I had been the fortunate recipient of a Getty Images Grant for Good. My plan was to document a sanctuary in

Sulawesi, Indonesia, that harbored animals who were victims of the international outlaw animal trade. But with a baby in my belly and malaria lurking on the island, I was destined to find another place to make pictures. My focus in Indonesia would have been endangered animals and, more importantly, the indicator species—the keystone like the red wolf, the jaguar, or the orangutan—that if saved would save countless other creatures as well.

When I found Wolf Haven, I felt blessed.

Wolves are difficult subjects for a photographer because they truly hate having their pictures taken, or even to be stared at for that matter. So I had to prove that I wasn't a threat, and this took some precious time.

I portrayed the wolves as though I had met them in a natural forest. Sometimes I showed the fence to present the truth of their lives there. The land at Wolf Haven comes as close to the environment of their births as possible. The wildness of their surroundings that had been stolen has been returned in the gift of true sanctuary.

In the summer, I spent long days with Jesse James, a female gray wolf, and her partner, Shiloh. I sat on my dad's old folding artist chair, surrounded by moss trees with birds and insects buzzing around and the sun glinting through. I pretended not to be interested in them at first, but as soon as I walked away, I turned around and there both of them were at the fence, smelling and staring at me. They want me to come back? When I did, they would disappear again. Ugh! This went on for weeks or more, until finally they began to trust me.

In the quiet of the forest, I watched their beautiful friendship unfold before me.

Jesse would appear then disappear behind trees, then appear again right in front of me, unaware, striking, and powerful. And then she was with me. An ancient being within reach. Behind us both was our history,

our loving mothers, our families, and the homes and forests where we grew and that we both missed dearly.

I sat with them for hours to uncover a moment of connection between two beings. I often used lighting to show the hidden intricacies of their beauty: the dirt on their fur, their sharp teeth, and their arresting eyes that can often be hidden by shadows. At first I was afraid of their ferocity and their unsettling stillness. I also feared not being able to capture their exquisiteness on film, but slowly I began to take them in and to envision their incredible existence. I thought of their need for connection to one another, incredible sense of smell and eyesight, their heightened awareness of everything encircling them, and their ability to remain calm, most of the time, through it all.

We connected through our eyes and, I believe, our hearts. How much I will miss you, sweet Jesse and Shiloh. Jesse passed away from complications of old age this past year within days of Shiloh's sudden death. They were truly in love.

Driving back to town where lives rush by and begin and end, I thought about the wolves and the silence in the sanctuary. I saw the sun piercing through their fur as it glowed and could feel myself sitting quietly in nature, paws crushing through the grass.

Animals connect me to my true self. I ache to have a second of their exquisiteness. There is an inner quiet and peace that can only be found while lost in the woods and meeting a gaze with a wolf or a raven or an owl. A wonderful dream. I tried to manifest that feeling in these pictures.

I photographed through small holes in an incredibly strong fence that protected me. But it couldn't keep me from falling deeply in love with these highly intelligent, beautiful beings.

—ANNIE MARIE MUSSELMAN

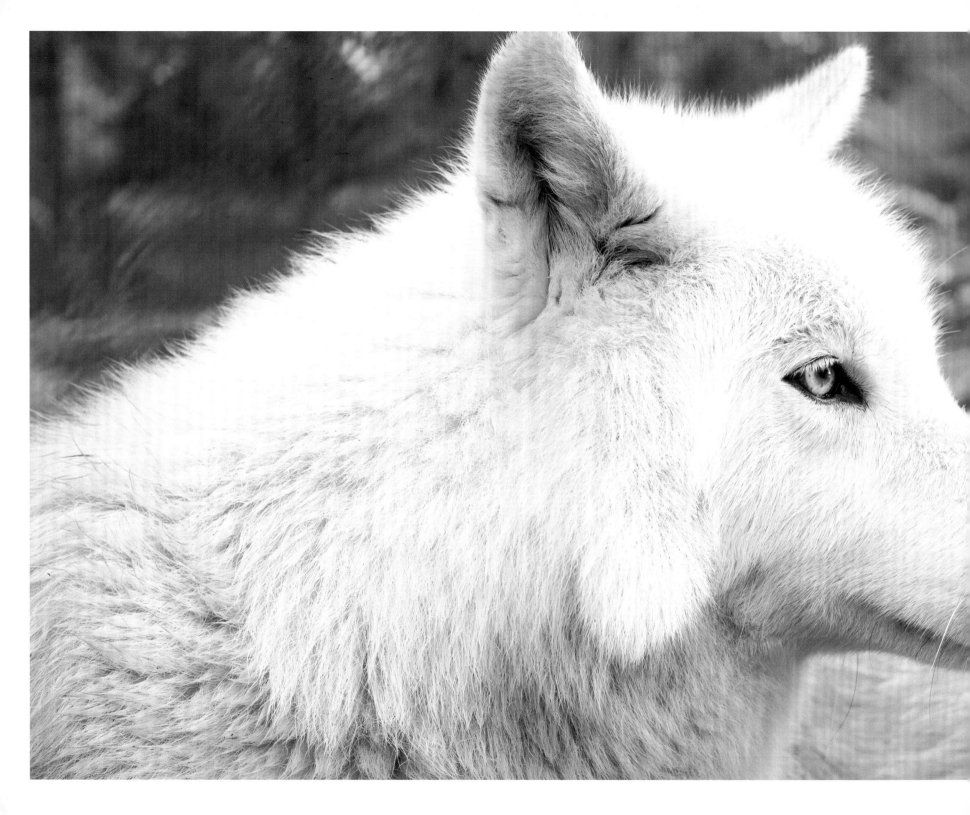

ACKNOWLEDGMENTS

ANNIE MARIE: *Wolf Haven* the book would have only been a dream were it not for the amazing humans (and animals) listed below.

Thank you . . . to my husband, Josh, whose handsomeness, wit, and ability to speed clean anything has helped keep me happy and alive. To my Chicken dog, who is my first baby and best photo shoot and beach companion a girl could ever want. For the Baby Beast, Jude Francis, who won't stop eating and keeps me outside while the house gets dirty. For my little Maggie Scout, who never eats and reminds me to stay inside and appreciate home. For Faith, my oldest friend who came from the heavens when I was desperate for a nanny and whose jokes and shenanigans never bore me. For Angel, a raven, who I keep in my heart and soul and who luckily has never left. For my parents, who taught me that to be in nature is of primary importance. Thank you, radiant beaches in West Seattle, where I've found a place to sit with my dog and daydream.

Thank you to Getty Images and their Creative Grant Program, for without it I would never have found Wolf Haven.

For all my friends at Wolf Haven, Wendy, Diane, Jim, Pam, Ursula, Kim, the list goes on; thank you for trusting me with the wolves and for making Chicken and me always feel like family. For Jesse James, my lovely friend who brought me gently into your world. And, Jesse, I'm still there. To Liz

and Mike at Cafe Vita for their relentless support of my work and their constant love of a great cause. And finally to Noisette, if it hadn't been for my room in your home in the city of lights, with the books and the photos, well, it may never have happened at all.

And to the rest of these beautiful beings, I'm so grateful for you: Blue Earth Alliance, Jane G., Kiki and Ed, Bella, Dayna at Panda Photo, C & P Coffee, Gary Luke, Suzy, Jeff and Freedom, Jane, Dodo, the Star Spangled Monkey Machines, Vitos Soccer, Christie at CS, Kylene, Richard Z. at RedApes.org, Elizabeth at Moncure, Maria Christina Bianco, The Community School, Sally Avenson, Pavement, and the amazing filmmaker Tadd Sackville-West.

BRENDA: Wolves survive by forging strong, life-affirming alliances—and so do writers. I'm truly grateful to my co-author, Annie Marie Musselman, for her kind-hearted artistic eye; for my perceptive editor, Gary Luke, who brought another illuminating book project to me; to my beloved agent and co-author, Sarah Jane Freymann, who visited sanctuary wolves with me when we first met so many years ago. Much gratitude to Siberian Husky savior, Tracey Conway, for accompanying me to Wolf Haven and lending me her insightful editorial eye; to co-author and photographer, Robin Lindsey, for teaching me so much about light and other animals; to Vanessa Adams, for her competent and delightful editorial assistance. For three decades of astute editorial insights, I thank Marlene Blessing. Thanks so much to Sasquatch editor, Emma Reh, for reassuringly guiding us through bookmaking. I'm grateful for my brilliant researcher, Mike Scstrez, and his wife, Mary. Also my incredibly competent and resourceful editorial assistant, Hailey Dowling. Finally, this book would not exist

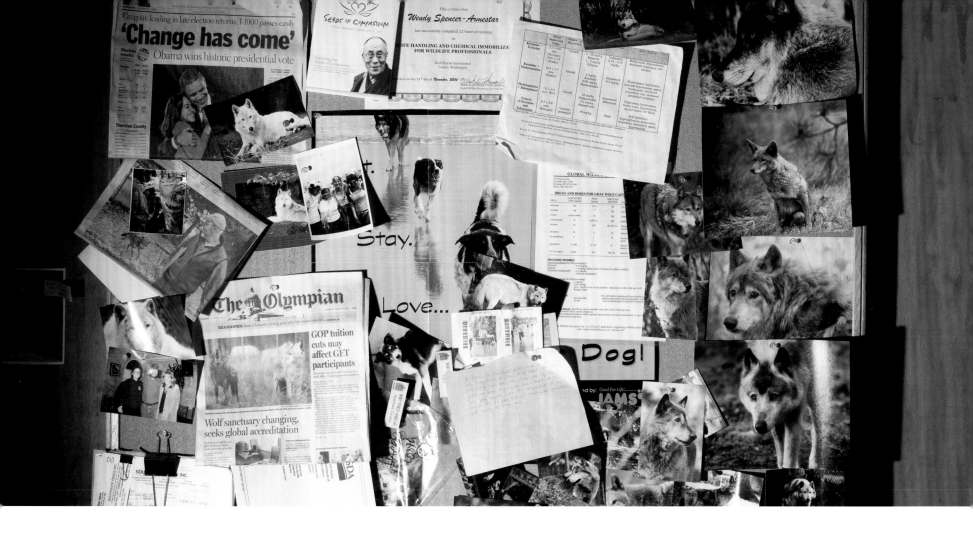

without the decades of devotion between people and wolves at Wolf Haven. Deep gratitude to Diane Gallegos, for her courage and compassion; to Wendy Spencer, for her fiercely intelligent and life-saving science; to Kim Young, for always calling us to community, like the wolf's howl. Happy thanks to Loki, Tao, Ella—daily companions. As always, I'm grateful to my family, three generations, who embrace other animals as extended kin.

ABOUT THE PHOTOGRAPHER/AUTHOR

ANNIE MARIE MUSSELMAN was born south of Seattle in a quiet town surrounded by deep forests and cold water. As a child she accompanied her artist father as he captured the landscape in watercolors. She later majored in studio art at a small Midwestern college, and spent a year studying photography in Marseilles, France.

Annie's first book *Finding Trust* was published in 2013 by Kehrer Verlag in Germany. The book documents a Wildlife Rehabilitation Center seventy-five miles north of Seattle, Washington. Her work can be seen in the *New Yorker*, *National Geographic Magazine*, *Audubon*, *Wired*, *Travel + Leisure*, and *Smithsonian* among others. Learn more at **AnnieMusselman.com**.

BRENDA PETERSON is the author of nineteen books, including the National Geographic's *Sightings: The Gray Whales' Mysterious Journey* and *Build Me an Ark: A Life with Animals*. Since 1993 Peterson has covered wolf issues for national medias, including the *Seattle Times*, *Christian Science Monitor*, and *Huffington Post*. Learn more at **BrendaPetersonBooks.com**

WOLF HAVEN
INTERNATIONAL

Wolf Haven International is an internationally accredited wolf sanctuary located in Tenino, Washington, that has rescued and provided a lifetime home for two hundred displaced or captive-born animals since 1982. Learn more at **WolfHaven.org**.

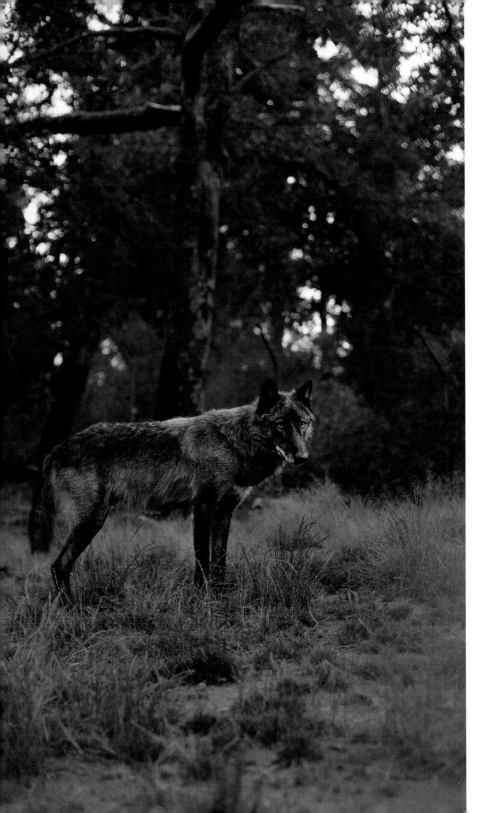

For the beast, the chicken and my baby lady —A. M. M.

For the wolves, First People, enduring teachers. May they return to the wild—everywhere. And for the compassionate people of Wolf Haven, who understand that when we are humane, we become more human. —B. P.

Printed in China

Published by Sasquatch Books
20 19 18 17 16 9 8 7 6 5 4 3 2 1

Editor: Gary Luke
Production editor: Emma Reh
Design: Joyce Hwang

Library of Congress Cataloging-in-Publication Data is available.
ISBN: 978-1-63217-051-4

Sasquatch Books
1904 Third Avenue, Suite 710
Seattle, WA 98101
(206) 467-4300
www.sasquatchbooks.com
custserv@sasquatchbooks.com

Portions of the text appeared in Brenda Petersons's June 2015 *Ampersand* article, "Living with Wolves, Losing Our Orcas."

Several of the wolves pictured in this book are involved in a breeding program that is part of an effort of reintroduce wolves into the wild to reverse their critically endangered status:

Moss, Mexican gray wolf: Stud number M1066
Unnamed Mexican gray wolf pup: Stud number M1425
Jacob, male red wolf: Stud number M1405